IMAGES
of America

FLAT ROCK

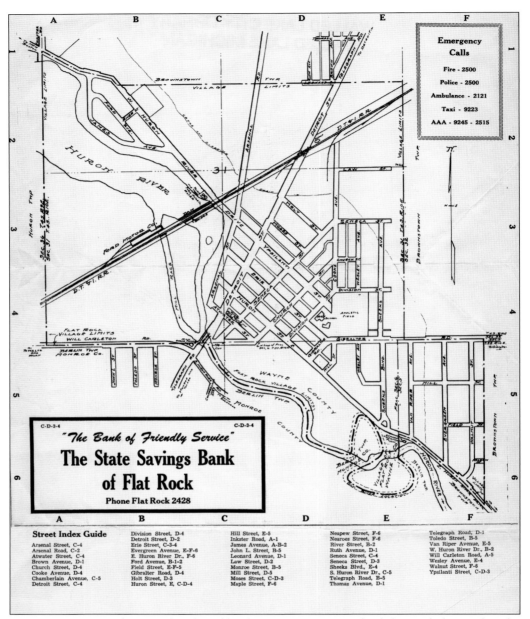

Street Index Guide

Arsenal Street, C-4	Division Street, D-4	Hill Street, E-5	Neapew Street, F-6	Telegraph Road, D-1
Arsenal Road, C-2	Detroit Street, D-2	Inkster Road, A-1	Nearoes Street, F-6	Toledo Street, B-5
Atwater Street, C-4	Erie Street, C-3-4	James Avenue, A-B-2	River Street, B-2	Van Riper Avenue, E-5
Brown Avenue, D-1	Evergreen Avenue, E-F-6	John L. Street, B-5	Ruth Avenue, D-1	W. Huron River Dr., B-2
Church Street, D-4	E. Huron River Dr., F-6	Leonard Avenue, D-1	Seneca Street, C-4	Will Carleton Road, A-5
Cooke Avenue, D-4	Ford Avenue, B-1-2	Law Street, D-2	Seneca Street, D-3	Wesley Avenue, E-4
Chamberlain Avenue, C-5	Field Street, E-F-5	Monroe Street, B-5	Sheeks Blvd., E-4	Walnut Street, F-8
Detroit Street, C-4	Gibralter Road, D-4	Mill Street, D-5	S. Huron River Dr., C-5	Ypsilanti Street, C-D-3
	Holt Street, D-3	Moses Street, C-D-3	Telegraph Road, B-5	
	Huron Street, E, C-D-4	Maple Street, F-6	Thomas Avenue, D-1	

MAP, 1948–1949. This map distributed by the State Savings Bank of Flat Rock depicts founder Michael Vreeland's original streets—Church, Seneca, Detroit, Arsenal, Huron, Erie, and Ypsilanti—which he platted in 1834. (Winnie May Oestrike Hamilton Collection of Flat Rock Historical Society.)

ON THE COVER: METLER SAWMILL, 1893–1913. Sawmills played an important role in the development of towns. As settlers arrived to new areas, there was a large need for lumber to build homes and businesses. This sawmill was owned by Marshall Metler and later became known as George W. Metler and Son's Manufacturers of Flour and Lumber. (Winnie May Oestrike Hamilton Collection of Flat Rock Historical Society.)

IMAGES
of America

FLAT ROCK

Stacey L. Reynolds and the
Flat Rock Historical Society

ARCADIA
PUBLISHING

Published by Arcadia Publishing
Charleston, South Carolina

Printed in the United States of America

Library of Congress Control Number: 2010937735

For all general information, please contact Arcadia Publishing:
Telephone 843-853-2070
Fax 843-853-0044
E-mail sales@arcadiapublishing.com
For customer service and orders:
Toll-Free 1-888-313-2665

Visit us on the Internet at www.arcadiapublishing.com

*This book is dedicated to Autumn, Bryan, Christopher,
and Justin, to their histories and futures.*

CONTENTS

Acknowledgments 6

Introduction 7

1. Honoring Our Heroes 9

2. Making a Living 33

3. Around Town 59

4. Churches, Schools, and Sports 87

5. Notable Names 105

6. Memory Lane 119

Bibliography 125

Index 126

About the Organization 127

Acknowledgments

This project would not have come to fruition if it were not for Prof. Joseph Turrini asking after a presentation about the Oak Forest Cemetery for my Public History Administration class, "How can you expand this project?" With this question in mind, I realized the next step would be to write a book about the history of Flat Rock.

A debt of gratitude is owed to Lila Fedokovitz, local historian, and volunteers Roberta Gonyea, Charlene Smith, Kathy Fisk, Carol Klingel, Tom Wyman, and Carol Matthews for offering to assist with the research and proofreading for this book. Sincere thanks to Cindy and Don Fesko, the president and vice president of the Flat Rock Historical Society, for having confidence in me to take on this project for the society.

Thanks to all the staff of the Flat Rock Library who granted access to the collection while Lila was away. Special acknowledgment must be given to Winifred May Oestrike. Winifred "Winnie" May Oestrike served on the Flat Rock Historical Commission since it was first formed on February 7, 2000. Winnie was a noted area historian, and she had amassed a large collection of photographs and newspaper articles related to the Flat Rock area. In 1980, she became the historian for the Flat Rock Historical Society. After Winnie passed away on December 25, 2002, her family donated her entire collection to the Flat Rock Library. The Flat Rock Historical Society staffs the local history room located inside the library. Unless otherwise noted, all photographs shown in this work are here courtesy of the Winnie May Oestrike Hamilton Collection of the Flat Rock Historical Society.

It is with much love that I dedicate this book to my husband, Jeff, for his continual support; to my friend Jim who constantly challenges me to imagine my future and obtain my dreams; to my brother Jeff and sister-in-law Tina, who cheered me on to complete this project; and to my mom, Chris, and grandma Ann, who never stopped believing in me.

INTRODUCTION

Flat Rock was once covered with towering virgin forests containing oak, hickory, beech, elm, and maple trees. The Huron River sparkled with clean, clear water full of many varieties of fish, such as sturgeon, pickerel, pike, and bass. The forests were home to wolves, bears, wildcats, deer, squirrels, and raccoons. It was this pristine landscape that drew the earlier pioneers to the area. The promise of the riches the land offered encouraged the settlers to stay.

Long before white settlers arrived in Michigan, American Indians had established villages along the banks of the Huron River. Missionary reports dating back to the 1700s indicate the presence of American Indians in the area. The natural water ways, extensive wildlife, and abundance of food in the Flat Rock area proved to be a draw for the Huron, Potawatomi, Seneca, Wyandot, and Algonquin Indians.

The first mention of other settlers in the area later to become Flat Rock was made by a French priest named Fr. Jean Dilhet. In describing his parish in 1798, he included "Grosse Roche," referring to a settlement named after the outcropping of limestone rock on the south side of the Huron River.

In 1818, the government settled a treaty granting a tract of approximately 5,000 acres of land on the Huron River to the Native Americans. Over 100 American Indians, comprised of Wyandot, Huron, and Seneca, resided on the reservation. The Indian reservation lay on both sides of the Huron River and was located in the southeast part of Huron Township—it extended to within a half of a mile of the village.

Doug Donnelly wrote that Michael Vreelandt is considered to be the founder of the settlement that became Flat Rock. Vreelandt arrived to the area with his five sons and their families in 1823 and bought approximately 640 acres from the federal government. The Vreelandt family owned most of the acreage that comprises Flat Rock today. The Vreelandt families built the first grain and lumber mills, bringing the grinding stones from New York. The village was originally called Vreelandt, but there was also a small area near the Huron River known as "Smooth Rock." On April 6, 1838, the town became known as Flat Rock in an agreement with the Gibraltar and Flat Rock Land Company. In 1923, Flat Rock was incorporated as a village and as a city in 1965. It is interesting to note that there were originally four different spellings of the Vreeland name: Vreelandt, Freeland, Von Vreelandt, and Vreeland. Eventually the spelling of Vreeland was agreed upon.

In 1842, the Indian tribes were forced to leave the reservation and were moved to Kansas. The reservation land was sold to Henry and Orville Moses, P. A. Chamberlin, Henry Wagar, and L. Stoflet by the government. Many of the tribe members left the area; however, reminders of their presence were found in the 20th century. The headstone of the last chief, Quaqua, was found in an abandoned Indian burial ground, just across from the Huron River Park Monument in 1906. In 1855, Anonias Wagar found a bag of gold worth $37 after leaving Katie Quaqua's (granddaughter of the chief) house. It is believed that the Native Americans would bury part of their payment

received from the government for safekeeping. After the tribe was removed, Katie visited the area once a year, and the locals believed she had money buried in the vicinity. Katie Quaqua was the wife of James Clark, who lived in Amherstburg, Ontario.

With the opening of the Erie Canal in 1825, large numbers of people, especially from New York, came to Michigan to settle. By 1828, the village had four stores, two sawmills, a wool carding mill, a flour mill, and 250 inhabitants. The village of Flat Rock was platted and recorded in 1838 by the Gibraltar and Flat Rock Land Company. The Gibraltar and Flat Rock Land Company was incorporated for the purpose of building a canal along the Huron River and connecting it from Lake Erie to Lake Michigan. The attempt to connect the canal ultimately failed. About three miles were completed when a bank panic hit Michigan. Traces of the canal can still be found in some areas of Flat Rock.

Flat Rock men were no stranger to the wars, including the Civil War. Some served in the 4th regiment and others in the cavalry and medical units. However, many men from the area served in the 24th Michigan regiment, which formed in the summer of 1862. Lt. Walter H. Wallace enrolled 47 recruits from Brownstown Township. The Iron Brigade is one of the most famous infantry units of the 24th Michigan Regiment.

Henry Ford was attracted to the waterpower of the Huron River, and in 1925 he established the Ford Motor Company headlight assembly plant along its banks. Henry Ford's "village industries" helped develop rural communities, such as Flat Rock. Believing that farming was not a full-time job, Ford felt the incomes could be supplemented with small industries and help preserve the lifestyle in rural areas. In November 1925, the plant started manufacturing all headlights and taillights for all Ford vehicles. The doors stayed open until 1950 when the work was moved to the Ford Stamping plant in Monroe, Michigan. The Detroit, Toledo, and Ironton (DT&I) Railroad greatly influenced the locations of the plants and mills along the Huron River and next to the railroad tracks. Flat Rock is home to architecturally significant buildings. These buildings date from a very prosperous time in Flat Rock's history. According to the Downriver Community Conference, the fact that these buildings are still around from the thriving times of the 1830s enhances the role of Flat Rock in terms of Downriver's history.

Flat Rock is home to the oldest Methodist Episcopal church in Michigan. In 1821, Rev. J. S. Finley was assigned to this area as an Indian missionary. After many years, he organized a society among the residents of the village. The first Methodist church was built in 1834. From 1833 to 1834, the society was known as the Smooth Rock and Wyandotte Missions. In 1838, the name changed to the Huron Mission. In 1851, the second church was erected and used for 51 years. A third church was dedicated on the same site in December 1902. The First Congregational Church of Flat Rock dates back to 1855.

Telegraph Road was constructed through Flat Rock and connected travelers to Dearborn and Monroe. The Huron River supplied waterpower, allowing for the establishment of three churches, a hotel, and a public hall. Businesses grew to include the production of timber, lumber, farm products, and mills. Flat Rock rapidly grew into the community it is today. Yet, even with its growth, it remains a unique small town, with many of its residents having roots reaching back to the 1800s. Enjoy exploring the history of Flat Rock through these images.

One

HONORING OUR HEROES

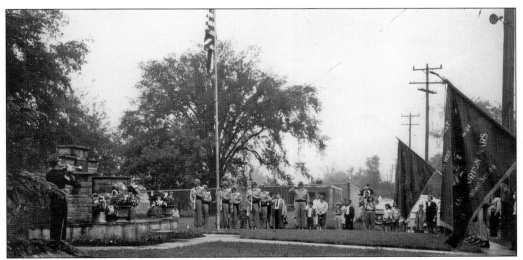

MEMORIAL SERVICE IN 1960 AT HUROC PARK BY HURON RIVER. In 1945, the Mom's Club of Flat Rock came up with the original idea of creating a veterans memorial to honor those who had made the supreme sacrifice in World Wars I and II. After two years of planning and setbacks, the first Flat Rock Veterans Memorial was completed and dedicated on Memorial Day 1947. It was later replaced by the veterans memorial located at city hall.

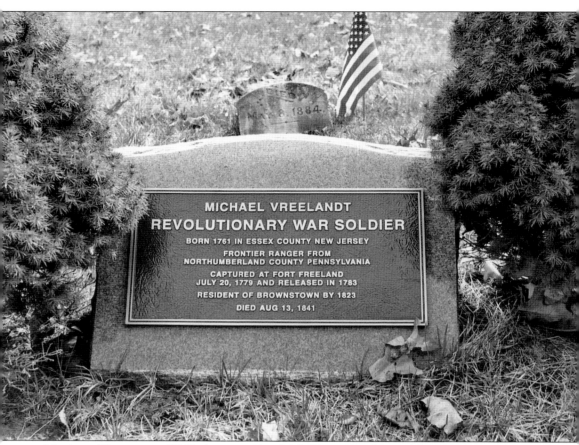

MICHAEL VREELANDT (1761–AUGUST 13, 1841). He was a soldier of the American Revolution. At the age of 18, he joined the war effort as a scout in 1799 and later served as a ranger on the frontier in a garrison at Fort Freeland in Northumberland County, Pennsylvania. He was captured at Fort Freeland on July 20, 1779, and was a prisoner of war for more than a year before being released in 1782. Legend has it Vreelandt was kidnapped as a young child from New York by Native Americans who brought him to the Flat Rock area. He returned to New York State as a young man and later returned to Michigan with his sons and their families. Michael Vreelandt is considered to be the founder of Flat Rock. (Ron Klingel.)

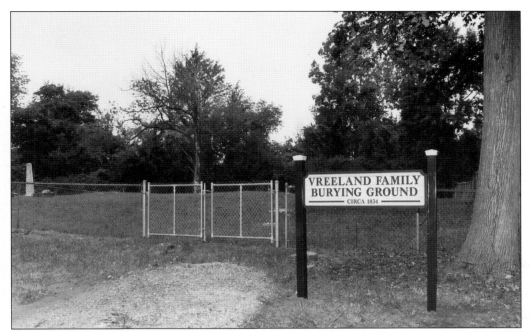

VREELAND FAMILY BURYING GROUND. This half-acre family cemetery lot is located north of Will Carleton Road and deeded on Vreeland property. Michael Vreeland, founder of Flat Rock, was buried here. His grave, along with other family members, was moved to Oakwood Cemetery. The cemetery is now fenced and maintained by a volunteer from the Flat Rock Historical Society. (Ron Klingel.)

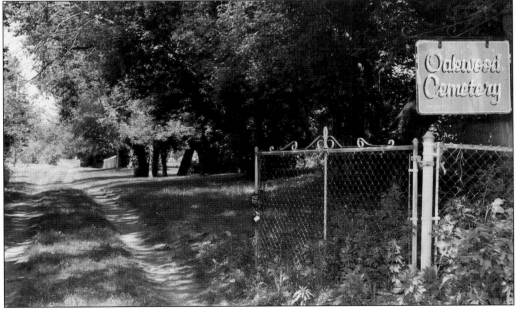

OAKWOOD CEMETERY. The cemetery is located on the north side of Will Carleton Road and 1 mile west of Telegraph Road. The original signers of the petition for the cemetery were residents of Flat Rock. The cemetery property in Huron Township was chosen for the sandy soil. (Ron Klingel.)

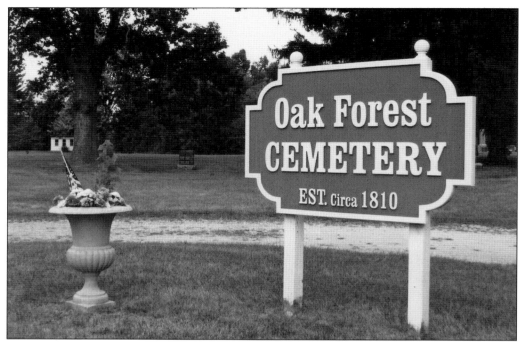

OAK FOREST CEMETERY. It is one of the oldest cemeteries in the downriver area, and there are just over 300 people buried there. Oak Forest Cemetery was established when Nancy Stoeflet Vreeland, widow of Elias Vreeland, son of Michael, donated a parcel of land on West Huron River Drive for a cemetery in the early 1800s. (Author's collection.)

EDWARD ANDERSON (SEPTEMBER 4, 1928–MARCH 17, 1969). He served during World War I. He was married to Marjorie Glass, the great-granddaughter of Dr. Hiram Lobdell.

WILLIAM A. ARMSTRONG (1843–JULY 25, 1869). On August 12, 1862, Armstrong enlisted in Detroit at age 19 to serve as a private in Company G, 24th Michigan Infantry during the Civil War. On July 1, 1863, he was wounded and his right arm was amputated. He was discharged due to his wounds on November 26 in Alexandria, Virginia. He came home to live with his parents and died shortly after. (Author's collection.)

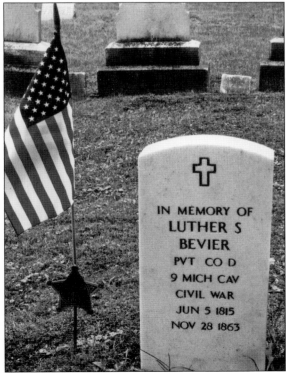

IN MEMORY OF
LUTHER S BEVIER
PVT CO D
9 MICH CAV
CIVIL WAR
JUN 5 1815
NOV 28 1863

LUTHER S. BEVIER (JUNE 5, 1815–NOVEMBER 28, 1863). A blacksmith, Bevier volunteered for Company D, 9th Michigan Cavalry in March 1863. In September, he was captured by Confederate soldiers outside Jonesboro, Tennessee, and interred in Belle Isle prison camp in Richmond, Virginia. Bevier died of dysentery two months later and is presumed buried there in an unmarked grave. Bevier's wife, Rachel, and two daughters are buried in Oak Forest. On September 24, 2005, a military marker for Pvt. Luther S. Bevier was dedicated there during a service that honored documented veterans in the cemetery. (Author's collection.)

WILLIAM ERASTUS BIGELOW (1830–1880). He served during the Civil War in Company D, 3rd New York Light Artillery Infantry. Originally a shoemaker from Fayette County, New York, he enlisted January 25, 1864, in Waterloo, New York. He mustered out on July 5, 1865, in Syracuse, New York, and became the Flat Rock constable in 1879. (Author's collection.)

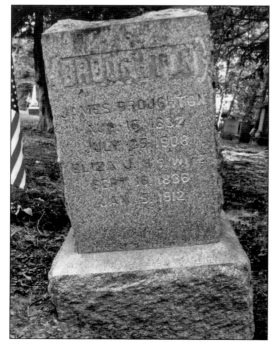

JAMES BROUGHTON (AUGUST 15, 1832–JULY 25, 1869). He served during the Civil War in Companies D and H, 8th Michigan Cavalry. Originally from New York, he married Eliza Vreeland. He received a pension of $16 a month for a gunshot wound to the left hand. The marker inscription reads, "Loving husband of Eliza Jane. Loving father of Charles, James Jr., Daniel, Lydia Jane, Sopronia, and Ada; beloved son of Mary and Richard." (Author's collection.)

REV. HENRY CARLTON (MAY 28, 1832–JUNE 6, 1863). Carlton served in Company L, 22nd Regiment Michigan No. 1. While standing guard on a train, Captain Carlton warned a guard to look out for an upcoming bridge. At the same time, a spark dropped into his eye and he raised his hand to remove the spark. Unfortunately, his attention was diverted from the coming danger. As the train passed onto the bridge, Carlton was struck on the head by timbers, knocked down between the cars, and killed instantly. (Author's collection.)

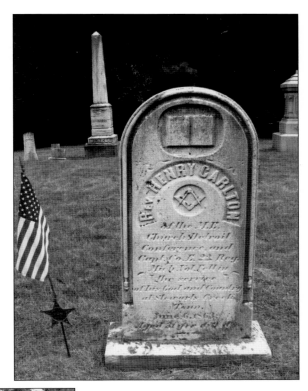

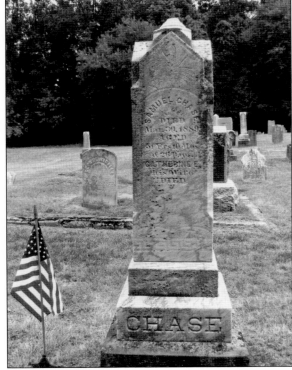

SAMUEL D. CHASE (MAY 4, 1837–MARCH 30, 1889). He served during the Civil War in Company H, 1st Michigan Infantry. His parents were Josiah and Lydia (Vreeland) Chase. He was a farmer. The inscription reads, "a. 51 years 10 months 26 days." (Author's collection.)

EDWIN S. DELONG (1841–MAY 6, 1864). He served during the Civil War in Company G, 24th Michigan Infantry. He died with many unidenitifed soldiers at Wilderness due to the fires in the woods after the battle. The inscription reads, "Killed at the Battle of the Wilderness in his 23rd year." (Author's collection.)

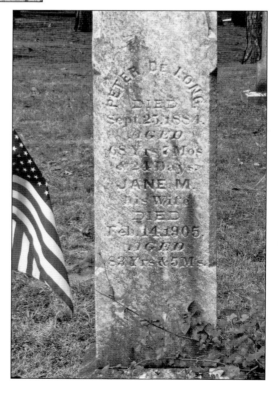

PETER DELONG (FEBRUARY 1, 1816–SEPTEMBER 25, 1884). He served during the Civil War in Company D, 4th Michigan Infantry. He enlisted in the same unit as his son-in-law, William James Vreeland, who was married to his daughter, Charlotte. He enlisted after his son Edwin was reported missing. The inscription reads, "Age 68 years 7 months 24 days." (Author's collection.)

GARRET GARRETSON (1829–JANUARY 7, 1877). He served during the Civil War in Company G, 24th Michigan Infantry. He enlisted on August 12, 1862, for three years and was discharged in York, Pennsylvania, on May 20, 1865. His wife, Minerva Armstrong, received $8 per month pension in 1883. His brother-in-law was Thomas Armstrong. He earned his living as a carpenter and was a member of the Masons. (Author's collection.)

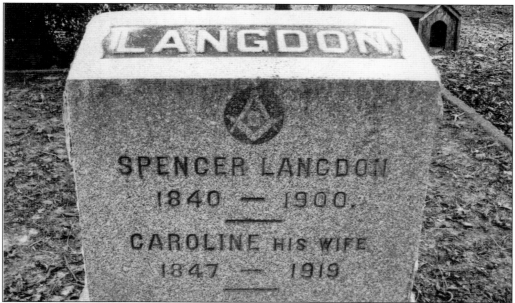

AMBROSE SPENCER LANGDON (MAY 5, 1840–FEBRUARY 12, 1900). He served during the Civil War in Company 1150, Pennsylvania Infantry. He enlisted August 30, 1862, and was discharged in May 1865 for disability. He married Caroline Van Riper and was an engineer at the sawmill. He became the minister and founder of the Christ Church Conneautville in Pennsylvania. He was wounded in action at Gettysburg with an injury to the abdomen and received $12 per month pension. (Author's collection.)

WESLEY B. LITTLEFIELD (1840–1914). He served during the Civil War in Company E, 1st Michigan Cavalry. He was the postmaster and justice of peace. His brother was Cyrus Littlefield. (Below, Stacey Lee Reynolds.)

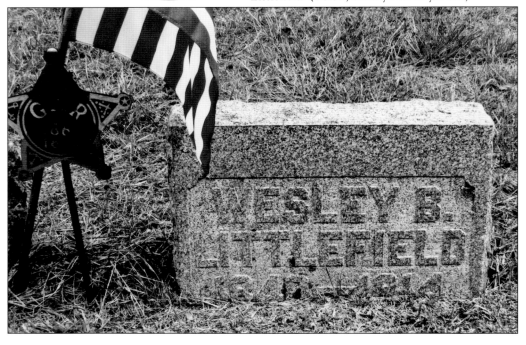

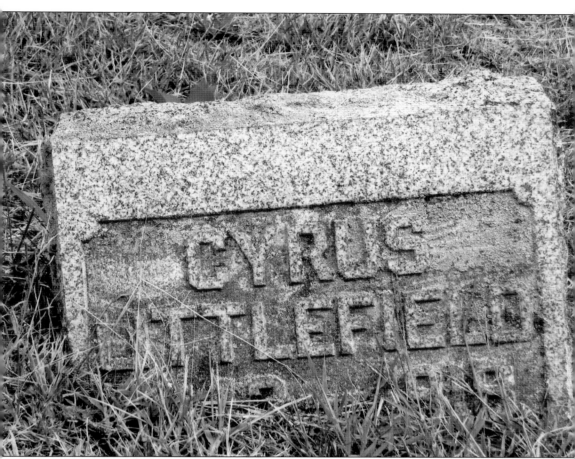

Cyrus Littlefield (1843–1918). He served during the Civil War in Company K, 1st Michigan Cavalry. His brother was Wesley Littlefield. During his second year in the army, he contracted typhoid. Later he went on trial for desertion, but because typhoid was found to have "affected his mind," the charges were dropped. He later died in an institution in Detroit. He received a $50 per month pension. (Author's collection.)

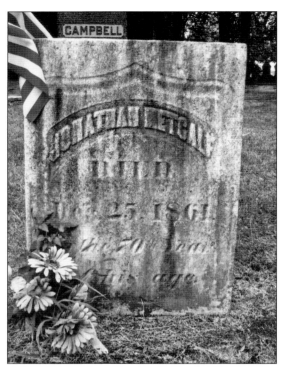

JONATHAN METCALF (1791–DECEMBER 25, 1861). He was originally from Seneca County, New York. He served in the McMahan's Regiment, New York Militia, during the War of 1812. The marker inscription reads, "In the 70th year of age." (Author's collection.)

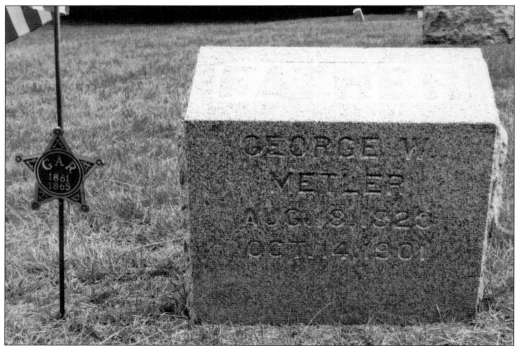

GEORGE W. METLER (AUGUST 18, 1820–OCTOBER 14, 1901). He served during the Civil War in Company E, 105th Pennsylvania Infantry. His family owned the local saw and grist mill. (Author's collection.)

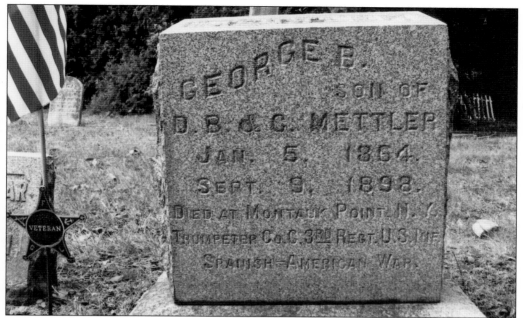

GEORGE B. METTLER (JANUARY 5, 1864–SEPTEMBER 9, 1898). Mettler enlisted into Company C, 3rd U.S. Infantry and served during the Spanish-American War, spending nearly 10 years in the army; he took part in the Santiago campaign and the assault on San Juan Hill. He was head bugler. While waiting to return home, Mettler contracted malaria and dysentery and died at Camp Wyckoff, New York. His body was shipped COD for a fee of $85. W. L. Potter found this charge outrageous and went to Gov. Hazen S. Pingree at the military headquarters. Pingree got the body released from the National Express Company; the state paid a reduced charge. Mettler's mother, Caroline Near, was the daughter of Dr. John L. Near. (Author's collection.)

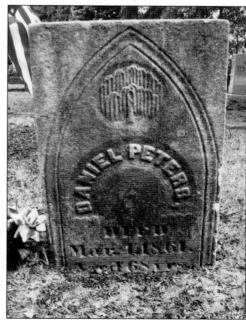

DANIEL PETERS (D. MARCH 4, 1861). He enlisted in the Rifle Company during the War of 1812 and was a private from Fayette, New York. (Author's collection.)

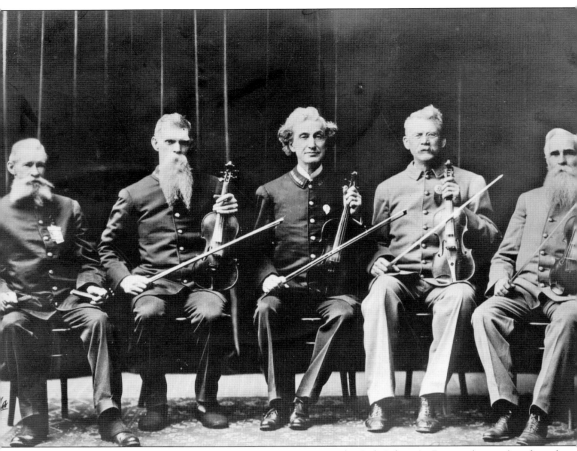

JOHN A. PATTEE (JUNE 5, 1844–DECEMBER 10, 1924). Col. John A. Pattee (center) enlisted into Company K, Michigan 24th regiment on August 5, 1862. After joining the Iron Brigade, he volunteered to man the Iron Brigade Battery, 4th U.S. Battery B. Pattee served with the battery for 18 months and mustered out with the regiment on June 30, 1865. Around 1904, he formed a vaudeville act called the Old Soldiers Fiddlers.

BENJAMIN W. PIERSON (1834–SEPTEMBER 23, 1883). He served during the Civil War in Company G, 24th Michigan Infantry. He enlisted on August 12, 1862, in Detroit as wagoneer. He mustered out on June 30, 1865, in Detroit and married Delia Kittle. The inscription reads, "Aged 49 years 3 months." (Right, Stacey Lee Reynolds; below, Tooney family.)

Lt. John L. Rogers [Roges] (October 9, 1829–January 6, 1869). He served during the Civil War in Company G, 4th Michigan Infantry and served in the same unit as Peter Delong.

Arthur E. Tann (1889–1917). He served during World War I and was enlisted in Company D, 1st U.S. Sig Corps. (Author's collection.)

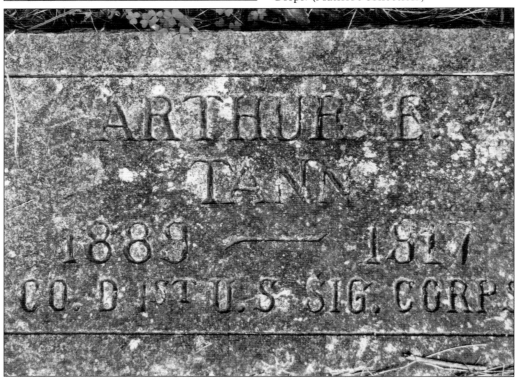

EDWARD TANN (DECEMBER 24, 1819–APRIL 10, 1874). He served during the Civil War in Company C, 100th New York Infantry. He worked as a cowboy, post-hole digger, and was zoo keeper at the St. Louis and Kansas City zoos. The inscription reads, "Born in London, England December 24, 1819, died in Flat Rock April 10, 1874." (Author's collection.)

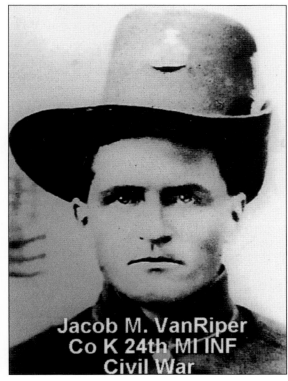

JACOB M. VAN RIPER (MAY 25, 1840–APRIL 14, 1926). He served during the Civil War in Company K, 24th Michigan Infantry and fought in the Battles of Gettysburg and the Wilderness. He was also part of the escort that accompanied Lincoln's casket to Springfield, Illinois. (Bob Coch.)

ELIAS D. VREELAND (1791–OCTOBER 31, 1846). Born in New York to parents Michael and Maria Vreeland, Elias served his country during the War of 1812. He was married to Nancy Stoflet (1802–August 5, 1881), and they had two children: Jacob Reese Vreeland and Susan Mary Vreeland. (Author's collection.)

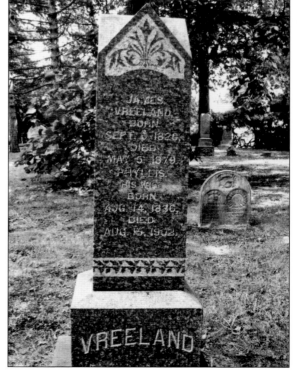

JAMES VREELAND (SEPTEMBER 6, 1820–MAY 5, 1879). He served during the Civil War in Company B, 5th Michigan Infantry. He was the son of Garret Vreeland. His first wife was Almira Vreeland, and they were married in 1843. He married his second wife, Phyllis Bushway, in 1860. (Author's collection.)

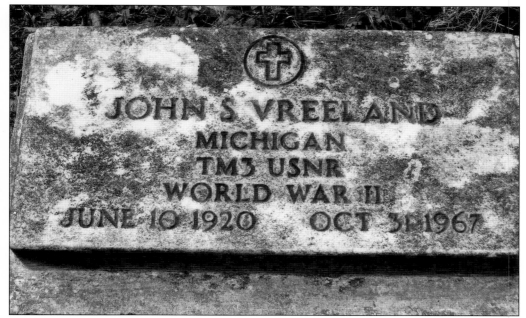

JOHN S. VREELAND (JUNE 10, 1920–OCTOBER 31, 1967). He served in the South Pacific in the navy during World War II in the Michigan TM, 3rd USNR and received a Purple Heart in 1944. He was the son of John and Mildred Vreeland. He is the fifth generation from founder Michael Vreeland. (Author's collection.)

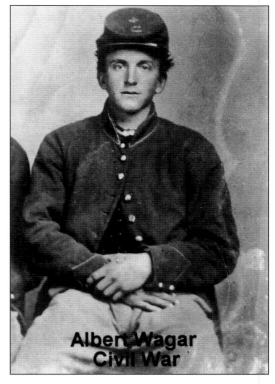

ALBERT WAGAR (JUNE 28, 1845–OCTOBER 8, 1936). He was the oldest son of Henry and Margaret Wagar. He enlisted in the 4th Michigan Infantry and served in Tennessee and Alabama. After being discharged June 12, 1866, he served as clerk, treasurer, and supervisor of Brownstown Township for several terms. He was married three times and had three sons (Fred, Harley, and Henry) with his second wife, Louisa Knight.

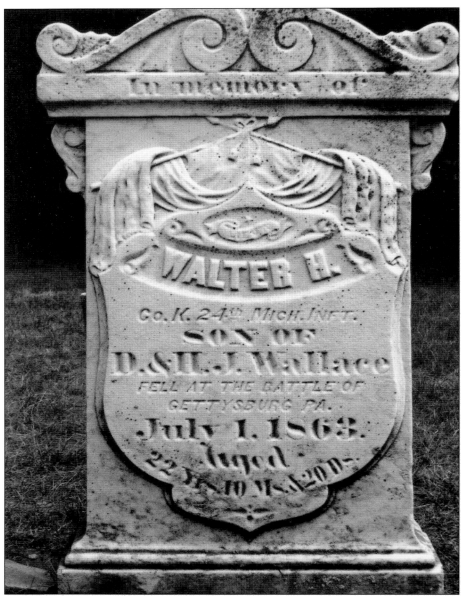

Lt. Walter H. Wallace (1840–July 1, 1863). He served during the Civil War in Company K, 24th Michigan Infantry. He first enlisted at age 20 into Company F, 2nd Michigan Volunteers Infantry as corporal on May 17, 1861. He obtained the rank of sergeant and was wounded in action July 26, 1862. He left the service due to the loss of his eye, but on August 9, 1862, he reentered the service as lieutenant of Company K, 24th Michigan Infantry. On this same day, he enrolled 47 recruits and was given a sword and belt by Dr. John L. Near. He served until he was killed in action by a piece of shell while doing his duty in the third line of battle beyond the ravine on the first day of the Battle of Gettysburg, Pennsylvania. After being killed in action at Gettysburg, his father went to Pennsylvania and recovered the body of his son and brought it back for burial in Flat Rock. The Flat Rock Grand Army of the Republic Post was named after Walter H. Wallace. (Author's collection.)

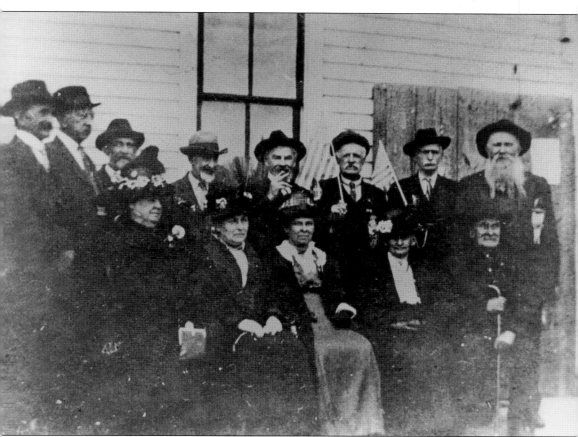

AREA CIVIL WAR VETERANS AND WIVES (1913). Grand Army of the Republic Veterans, Post 95 Walter H. Wallace pictured from left to right are (first row) two unidentified, Mary Strewing, Catherine Van Riper, and Jacob "Jake" Van Riper; (second row) Albert Wagar, two unidentified, Edmund Beach, John R. Brown, William Laura, unidentified, and Charles Strewing.

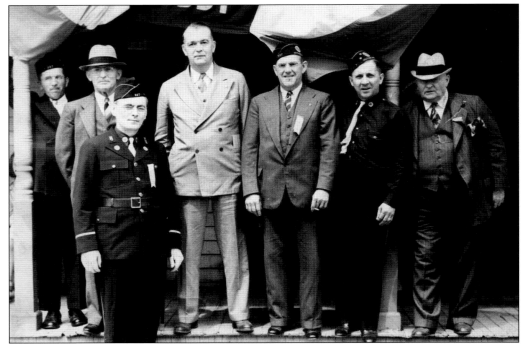

AMERICAN LEGION HOME DEDICATION (1939). The guest speakers included Secretary of State Harry Kelly and Governor Dickinson. Among those pictured, as marked on the back of the original photograph, are Julius Kornarski, August Bunte, Charley Cayley, Jessie Van Riper, Harry Kelly, Governor Dickinson, Ernie Fugmann, and Oscar Smith.

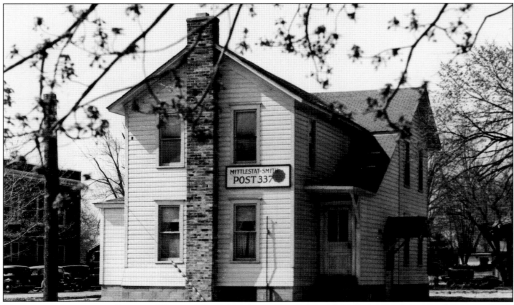

ORIGINAL AMERICAN LEGION HOME. The Mittelstat-Smith Post 337 dedicated this building on May 28, 1939. Located on the southwest corner at Ypsilanti and Division Streets, the building was torn down to make way for new construction. A new building was dedicated on February 1, 1964.

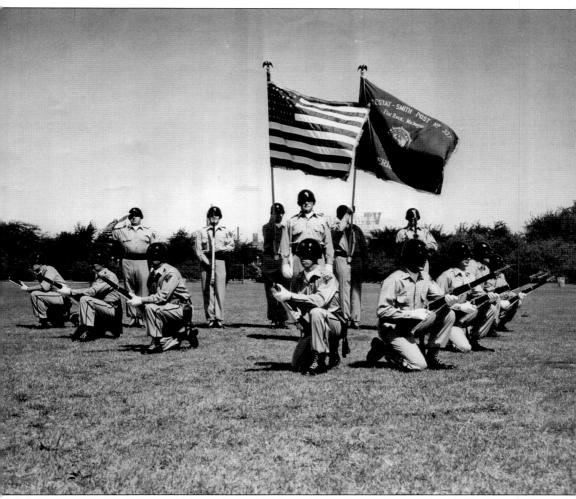

MITTLESTAT-SMITH AMERICAN LEGION POST 337 RIFLE DRILL TEAM. Organized in 1955, the team started participating in the Rifle Drill Team competition in 1956. They came in fourth place at the 1958 National Convention in Chicago and came in first place in the State of Michigan Champion Rifle Drill Team in 1959. Color guard members are, from left to right, "Bud" Squires, John Whipple, Dean Jones, Robert Bost, and Howard Buck. Drill team members are, from left to right, 'Red' Sworden, George Berkowitz, Dave Chambers, Roger Elias, William Gibbons, Ray Hood, Robert Hood, "Bernie" Sorrels, and unidentified.

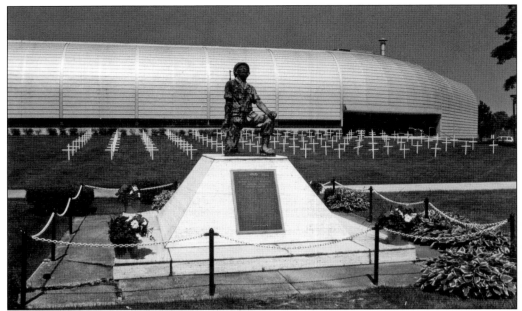

FLAT ROCK VETERANS MEMORIAL. After two wars that added the names of men who gave their lives, and due to the growth of the city, a new memorial and site had to be selected. The new memorial was designed and created by Florence Esten Kaufman, and the sculpture was dedicated on July 4, 1976. After many additions and improvements were made to the memorial, a rededication ceremony was held on May 27, 2002. This was sponsored by the American Legion Post 337 and Veterans of Foreign Wars Post 9363. The Veterans Memorial is currently located in front of the city hall on Gibraltar Road. (Above, Ron Klingel; below, Stacey Lee Reynolds.)

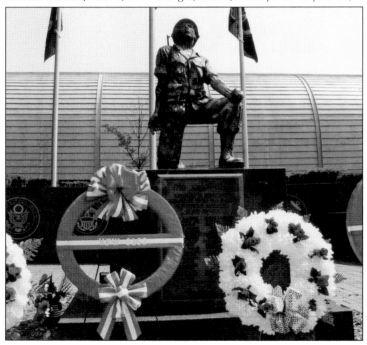

Two

MAKING A LIVING

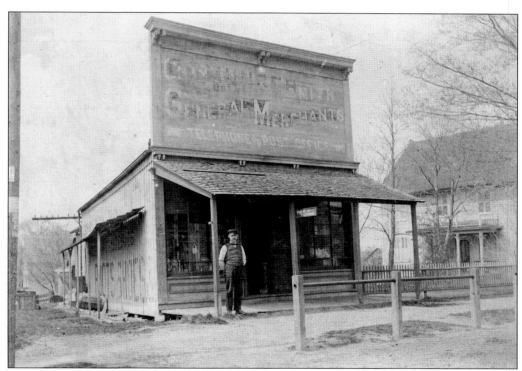

C. G. MUNGER GENERAL STORE. Originally built by Cornelius Munger in 1875, the store became a family operation when Edward Munger (pictured) joined his father in the business in 1895. The store was located on the east side of Telegraph Road, near East Huron Drive, until it was moved across the street to the northwest corner. The corner was a stagecoach stop for many years, and this store had the first public telephone between Detroit and Toledo, Ohio. The store served the community from 1875 to 1937. In 1976, the George Diamond family purchased the property and donated the building to the Flat Rock Historical Society, to be moved to a new location.

CORNELIUS AND FANNIE MUNGER. This image shows them behind the general store. Cornelius was postmaster from 1885 to 1889, and the service window can be viewed at the museum. He was the son of William and Maria (Springstead) Munger.

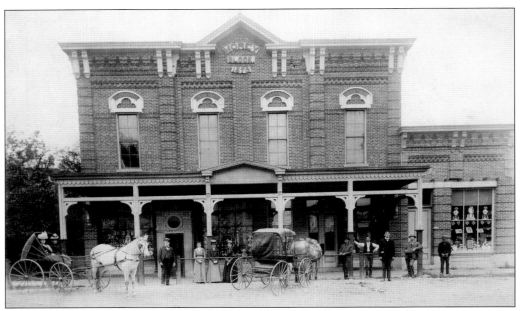

MOREY BLOCK BUILDING. People from left to right are Mrs. Henry Green's daughter, Mrs. Henry Green, Willet S. Money, Mary Flowers, Miss Parish, Mrs. John French, Barney Parish, James Garretson, Sara Navarre, William D. Leachran, and Ed Beach.

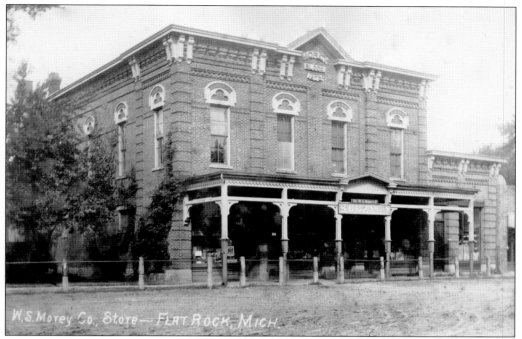

W. S. MOREY COMPANY STORE (BEFORE AND AFTER.) On Friday, September 28, 1912 at 11:30 p.m., one of the oldest and most prosperous stores in Wayne County, located on the northeast corner of Huron River Drive and Telegraph Road, caught fire. The building and merchandise were completely destroyed. A great loss was felt by the community and left many feeling stunned. The Morey stores had been a meeting place for many generations for the residents of the surrounding countrysides. The store was a place to barter and exchange goods. The fire also destroyed the two adjacent buildings, the Morey homestead and a bank. Through the courageous actions of the volunteer fire department, Jessie Van Riper's ice cream store and Dr. F. P. Hasley's drugstore survived the fire, but not unscathed. The heat was so intense that it broke all to the glass in the buildings.

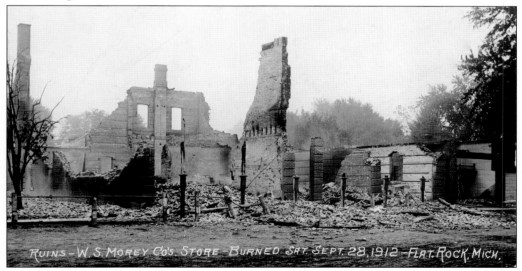

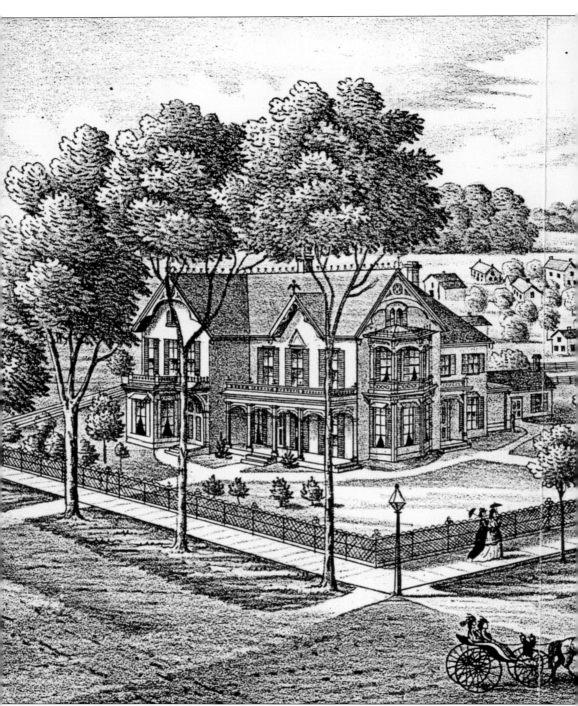

W. S. Morey Esquire (image from 1876 Atlas). Willet S. Morey was born in Duchess County, New York, on October 31, 1833. He came to Flat Rock in 1854, and he married Ellen Ransom. In 1855, he opened a general mercantile store. The business grew, and a new building was erected in 1875. The general store sold many items, including crackers, sugar, molasses, kerosene oil, and

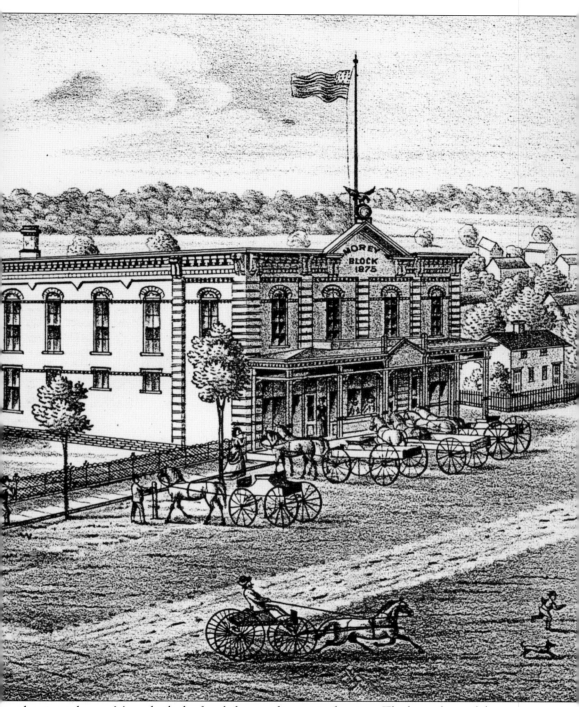

chewing tobacco. Morey built the family home adjacent to the store. The home burned down on September 28, 1912, with the same fire that destroyed the W. S. Morey store and the Flat Rock State Bank.

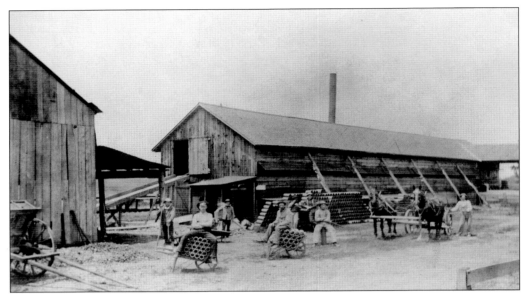

Bunte Brothers' Tile Yard at Arsenal Road, 1901. Henry J. Bunte, pictured above with gun, purchased the brick and tile machinery from Bennie Hall in 1901. He started out making bricks and then began manufacturing drain tiles. The clay was shoveled by hand into a horse-drawn dump cart and hauled up a clay path to the pit and dumped. The clay went through a crushing machine and was mixed with water in a pug mill and "muddled." A large auger carried the mud into a tile press, where it was cut into 12-inch lengths in various diameters. Then the tiles were placed in the shed, where they were dried by the air and sun. After the drying process, the tiles were baked in kilns and sold. At the beginning of the century, one could purchase 1,000 three-inch tiles for $10. Louise Bunte is pictured above with a wheelbarrow. The dry storage sheds pictured below held 300,000 tiles.

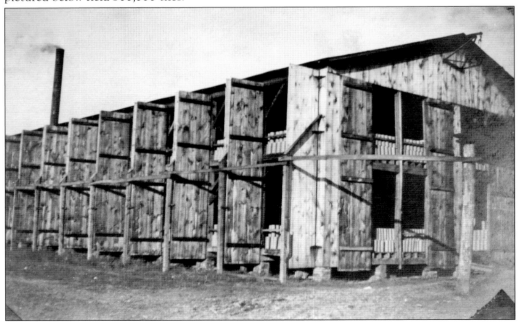

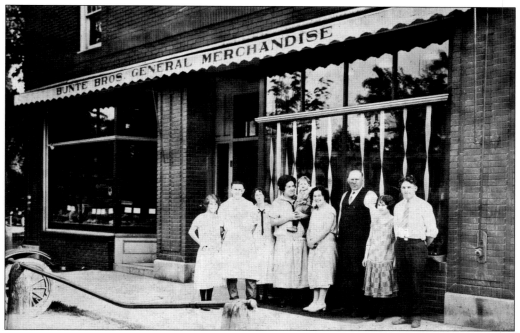

BUNTE DEPARTMENT STORE, 1928. The store was located on Huron River Drive on the site where the old Morey building stood. The store sold just about everything, had a meat department with a butcher, and hardware could be found downstairs. The business was sold in the early 1950s and became the Huron River Pharmacy. George Bunte is pictured above in the vest and his wife, Ellen Mae, holds baby Evelyn. Julius Niefert and Myrtle Wagar are pictured below behind the counter.

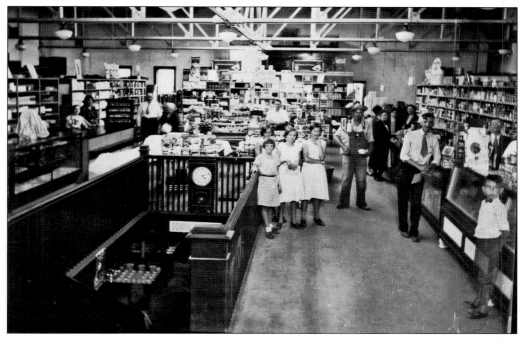

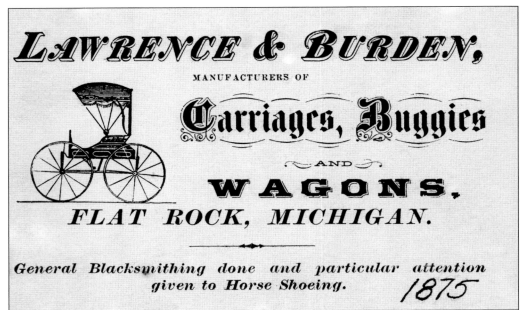

LAWRENCE AND BURDEN, GENERAL BLACKSMITHING. Fred Burden (b. February 24, 1848) learned the trade of blacksmithing in England and spent his early years working at his trade near London. At age 21, he came to Cleveland, Ohio, but moved to Flat Rock in 1872 and went into business for himself. He lived in Flat Rock for over 50 years with his wife and family and was one of most highly respected citizens of Flat Rock. (Gloria Dunn.)

BOULEVARD DAIRY COMPANY MILK STATION, 1920s. It was owned by Albert Upham and located west of Telegraph Road on West Huron River Drive at the railroad tracks. The creamery was a farmers' cooperative affair. Milk from the surrounding farms was brought in, and the farmers would gather at the bulletin boards to discuss the notices posted upon it. The making of cheese and butter proved not to be very profitable, and the operation changed so that the milk received at the creamery ended up being shipped by railroad to a Detroit creamery.

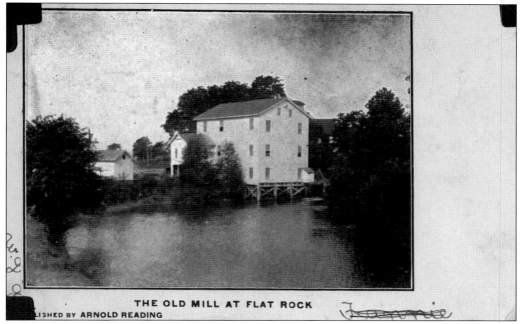

THE OLD MILL AT FLAT ROCK

LISHED BY ARNOLD READING

DIEKMAN FLOUR MILL. The mill was operated by Herman and Joseph Diekman. The mill was located at Will Carleton and Telegraph Roads, just a few yards from the former state police post. It was destroyed by fire in 1903. (Betty Law.)

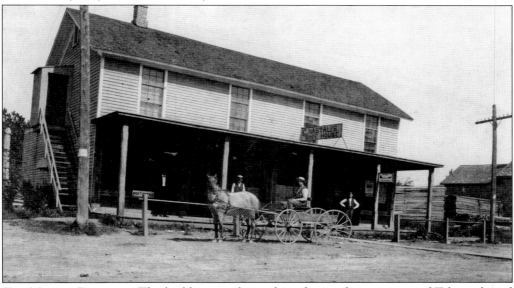

THE METLER BUILDING. The building was located on the northwest corner of Telegraph and Arsenal Roads. At the time of this photograph, the post office and C. Nastalis Shoe House were located inside. When the old school burned down in 1910, classes were held here until the new school was built. The last businesses in the building were the Flat Rock Café, owned by the Angelos Family, the Flat Rock Sport Shop, and Tony's Shoe Repair, owned by the Ancona family. The building burned in 1978 and was torn down in 1986. The lumber piled on the right is from the Metler Sawmill.

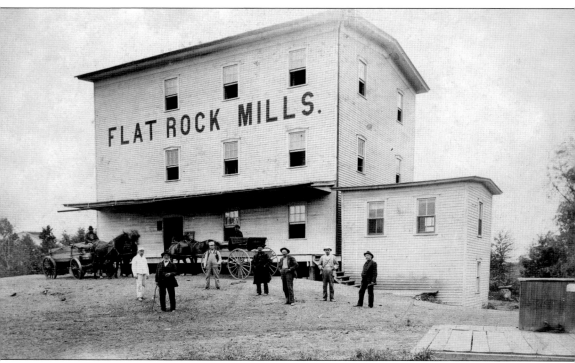

METLER GRISTMILL. The mill was originally located on Telegraph Road on the west side, just before the bridge into Monroe County. In 1872, George Washington Metler and Curtis Metler bought the land and tore down the existing sawmill to build a gristmill. Farmers used to come from all around with wagonloads of wheat and corn to be ground into feed and flour. Henry Ford bought the mill during World War I and then leased it to Frank Cornwell in 1918. In November 1965, the mill burned down.

GIL CAMPBELL (LEFT) AND CARSON METLER. Farming played an important role in this developing area. It was a common site to see wagons loaded with hay in town.

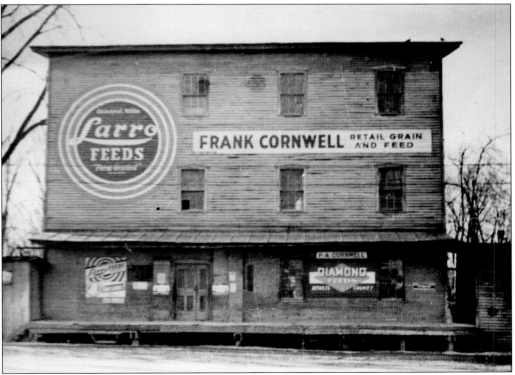

FRANK CORNWELL RETAIL GRAIN AND FEED. This was the old feed mill, which was leased from Henry Ford in 1918. Frank was born April 10, 1889, and died April 3, 1954. His parents were Georgianna and Benjamin. Frank married Irene Shaw at Clare in 1907. They had one daughter and two sons. He is buried in Michigan Memorial Park Cemetery. (Tom and Barb Stone.)

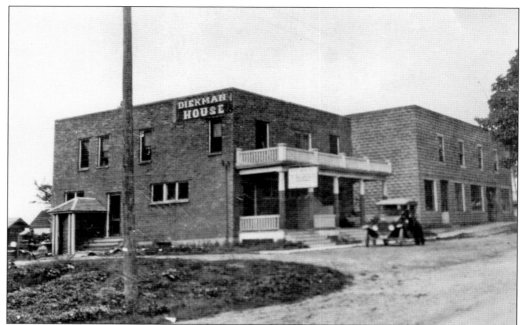

DIEKMAN HOUSE. This hotel, built by Pat Diekman, later became Rath's Little Pal in 1960. It is currently Michael's on the River restaurant/bar located on Telegraph Road.

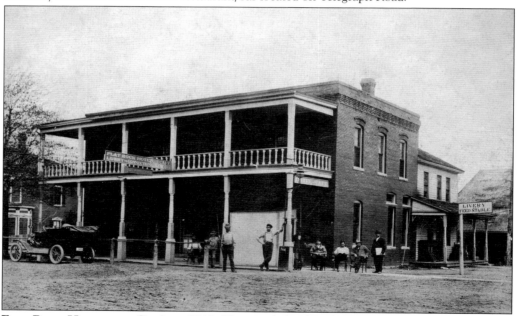

FLAT ROCK HOTEL AND CAFÉ, C. 1910. The sturdy brick Italianate Flat Rock Hotel was built by the Ferstle family during the summer of 1896. In 1906, Oscar Smith and his wife, Gertrude, arrived in Flat Rock by horse and buggy and purchased the hotel. Behind the building was a livery stable and behind that an icehouse. Pictured are, from left to right, Elija Driggert (son), Edward Drigget, Matt Winstone, Bert Winstone (son), George McCalla, Joe Diekman, Ed Lezotte, Otto Nefert, and Fred Laura.

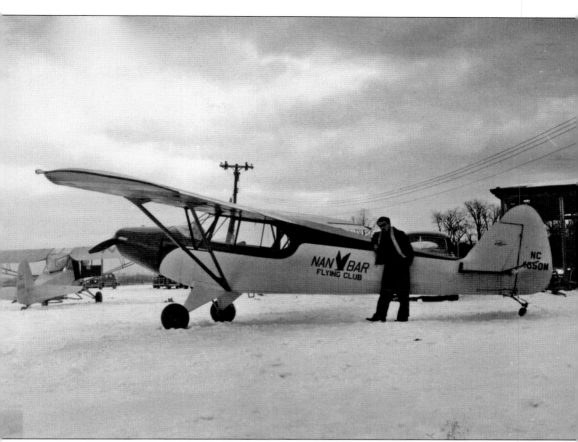

AIRPLANE, 1948. Robert Cornwell trained to be a pilot and worked at repairing and painting the planes at the Nan-Bar Airport (located north of Gibraltar Road and west of Cahill Road) in Flat Rock after World War II. The Nan-Bar Airport was owned by Red Stultz and was named after his two daughters, Nancy and Barbara. Cornwell and airport co-owner Chet Brazer flew along the Detroit and Ohio Edison power lines checking for burned insulators. Each month, the pair, armed with a map, flew 75 feet off-ground with Brazer piloting and Cornwell searching for burns and reporting their findings to Edison.

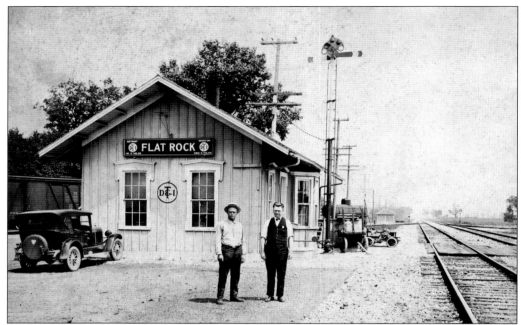

FLAT ROCK DT&I DEPOT. Flat Rock was once considered a "rail-road" town. The construction of a 140-mile railroad between Springfield and Pomeroy was started in May 1876 by the Springfield, Jackson, and Pomeroy Railroad Company and led many employees of the Detroit, Toledo, and Ironton (DT&I) to move to the Flat Rock area. After several years of financial difficulties and ownership, Henry Ford purchased an old failing railroad and renamed it DT&I on July 8, 1920, and operated successfully and profitably until 1929, when Ford sold his controlling interests. DT&I's operations ended on December 31, 1983, when it merged with Grand Trunk Western Railroad. Stationmaster Bill O'Connell (above, right) is pictured around 1930 and Dr. Hiram Cobbell (below, far left) is pictured in the 1920s.

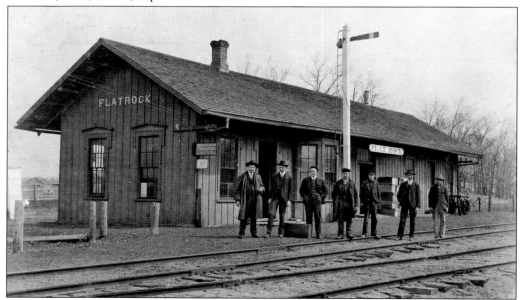

AL'S DINER. The diner was owned and operated by Al Howard from 1930 to 1945. The diner was a popular spot and served good, old-fashioned southern cooking. His teenage son Walt worked with him running the restaurant. Due to the shortages of food and help during World War II, Al closed the diner.

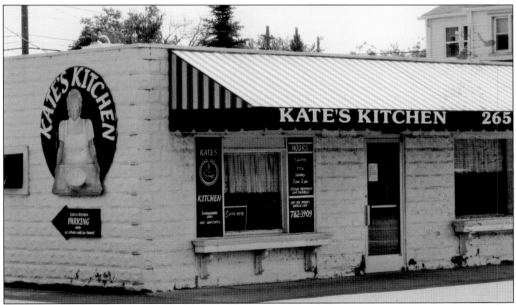

KATE'S KITCHEN. In 1976, Kate Gillespie began baking pies in her kitchen at home. She sold them to local restaurants and retailers, but soon the orders overtook the baking capacity in her home. Kate opened her restaurant in 1979 and gained a reputation as a great baker. After Kate's retirement, her daughter Catherine Zornischenko took over. Fresh-baked pies and biscuits can still be enjoyed at 26558 West Huron River Drive. (Author's collection.)

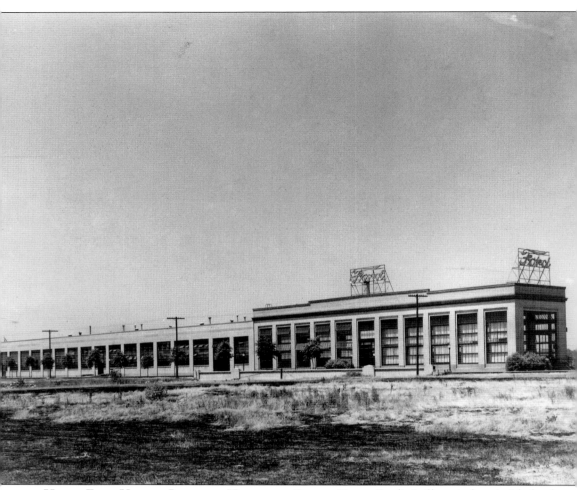

HENRY FORD VILLAGE INDUSTRY HEADLIGHT PLANT. Henry Ford's "village industries" helped develop rural communities, such as Flat Rock. Believing that farming was not a full-time job, Ford felt the incomes could be supplemented with small industries and help preserve the lifestyle in rural areas. In November 1923, the plant started manufacturing all headlights and taillights for all Ford vehicles. The doors stayed open until 1950 when the work was moved to the Ford Stamping plant in Monroe, Michigan. The acquisition of the Detroit, Toledo, and Ironton (DT&I) Railroad greatly influenced the plant's location along the Huron River and next to the railroad tracks.

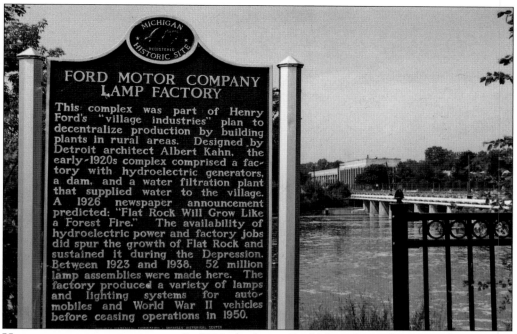

The image on the marker reads:

MICHIGAN
REGISTERED
HISTORIC SITE

FORD MOTOR COMPANY
LAMP FACTORY

This complex was part of Henry Ford's "village industries" plan to decentralize production by building plants in rural areas. Designed by Detroit architect Albert Kahn, the early-1920s complex comprised a factory with hydroelectric generators, a dam, and a water filtration plant that supplied water to the village. A 1926 newspaper announcement predicted: "Flat Rock Will Grow Like a Forest Fire." The availability of hydroelectric power and factory jobs did spur the growth of Flat Rock and sustained it during the Depression. Between 1923 and 1938, 52 million lamp assemblies were made here. The factory produced a variety of lamps and lighting systems for automobiles and World War II vehicles before ceasing operations in 1950.

Historical marker dedication. In 2008, the former Ford Motor lamp plant was acknowledged with a historical marker. Guests included Bob Kriepke, a Ford historian; Paul Larizon, CEO of Bar Metal Processing; and state representative Kathleen Law. Mayor Richard C. Jones unveiled the green and bronze marker. (Author's collection.)

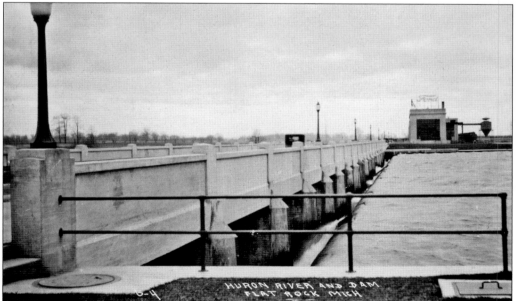

Huron River and Dam. The 365-foot dam was built to serve as a power plant for the Ford headlight plant, retain water in connection with the community waterworks, act as a railroad bridge, and an automotive highway. The dam raised the water level 7.5 feet at the mill gates, thereby generating 700 kilowatts of power.

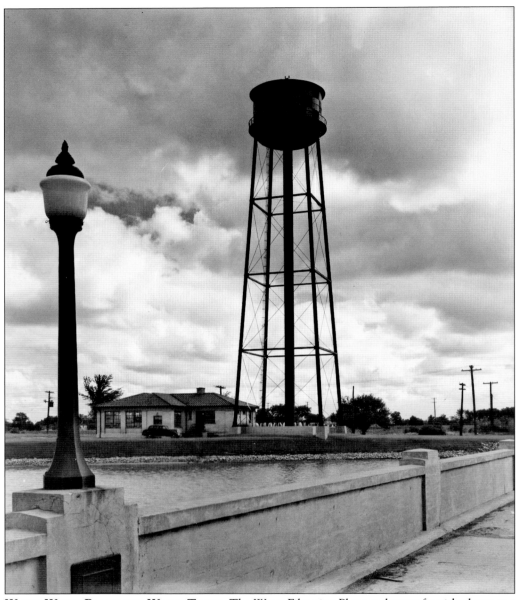

WATER WORKS PLANT AND WATER TOWER. The Water Filtration Plant and tower furnished water to the Lamp Plant, DT&I railyard, and the village of Flat Rock. Two towers were originally scheduled for delivery to the area. After the deliveries were made, it was discovered a mix-up occurred and the larger tower had been delivered to the railyard. Rather than reload them, they were installed as delivered. In 1924, water mains were installed, and additional mains were added as the town grew. Eventually the requests for water became so great that it was necessary to build a new water plant. It was built on the island in the park and opened in June 1957. The facility closed July 29, 1983, after the city council voted to connect to Detroit water. The contract with Detroit did not allow for storage facilities, so the water tower had to be taken down. Around this same time, the village offices were moved out of the old Masonic Temple and into the old waterworks building. When the new city hall was built, the waterworks building became the Senior Citizens Center.

HYDROELECTRIC POWER (RIGHT) AT FORD'S
LAMP PLANT. Albert Kahn was hired as
the architect for the Lamp Plant, dam,
and the water filtration plant (above). The
waterpower of the river was converted
into electric power by two water turbines
directly connected to two 350-kilowatt
generators. Mechanical governors
automatically opened or closed the water
gates when the speed of the generator
shafts fell below or exceeded 80 rpm. It
is interesting to note that the Flat Rock
plant would have the distinction of being
one of the first Ford plants to install a
power plant from one of the emergency
Fleet Corporations steel vessels, purchased
by the company for dismantling.

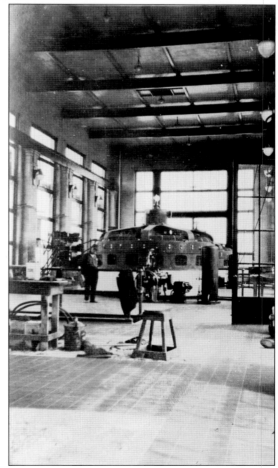

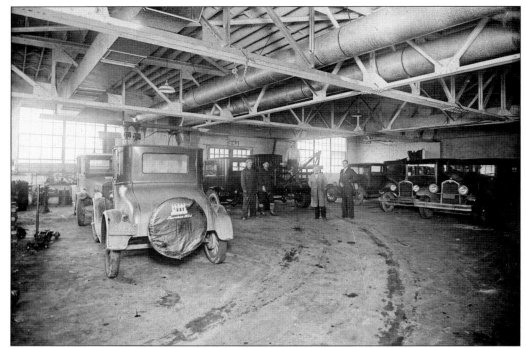

BURNHAM FORD AUTO SALES, C. 1928–1932. Located at the corner of Telegraph Road and Moses Street, the establishment was originally owned by George Van Riper and Walter Wright under the name Ford Sales and Service. In 1927, new proprietors Burnham Ford (the nephew of Henry Ford) and Thaddeus Moon advertised that they were aiming at providing continued service to the residents.

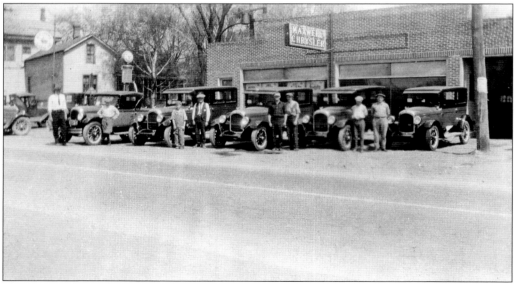

RICHARD OESTRIKE CAR DEALERSHIP, 1917–1961. Located on Telegraph Road, the dealership originally sold Dort Motor Cars manufactured in Flint, Michigan, and then sold Chrysler cars. They advertised as the "oldest Chrysler dealer in the United States."

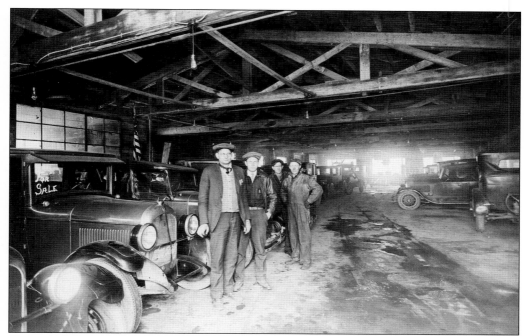

OESTRIKE'S GARAGE. From left to right are Richard Oestrike, John Langs, Johnnie Greer, and Chester Barnes. Richard Oestrike owned and operated the Richard Oestrike, Inc., garage from 1917 to 1961. He was born March 10, 1882, and died February 28, 1970. He was married to Mabel Carter and had three sons and two daughters. One of his daughter's was Winifred "Winnie" Oestrike, the local historian who served on the Flat Rock Historical Commission from its inception in 2000.

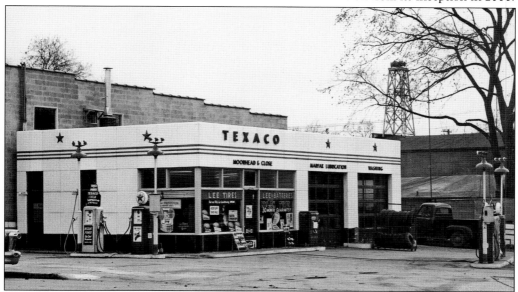

TEXACO GASOLINE STATION, OCTOBER 1958. The station was first managed by Clayton and Lawrence Dugan, than later managed by John Moorhead and Stuart Close. The station was located at the southeast corner of East Huron River Drive and Detroit Street (now Telegraph Road), which is where Ray Hunter Florist is located. (Bodary family.)

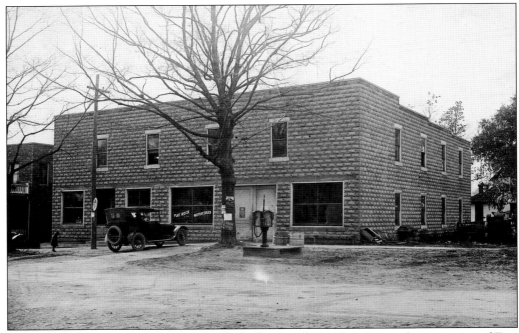

FLAT ROCK MOTOR SALES, 1920. The dealership was located at the southwest corner of East Huron River Drive and Telegraph Road. The Flat Rock Fire Department used to rent heated garage space for storing and drying hoses for $7.50 per month in 1925.

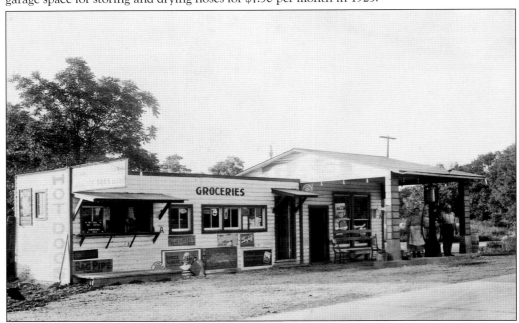

GRANDPA DIEKMAN'S GAS STATION. The first gas station and hamburger stand was located on Telegraph Road between Toledo, Ohio, and Dearborn, Michigan. It was owned by Joseph C. and Elizabeth Diekman. It was originally located across from the Michigan State Police Post at South Huron River Drive and Telegraph Road. (Gloria Burgess Dunne collection.)

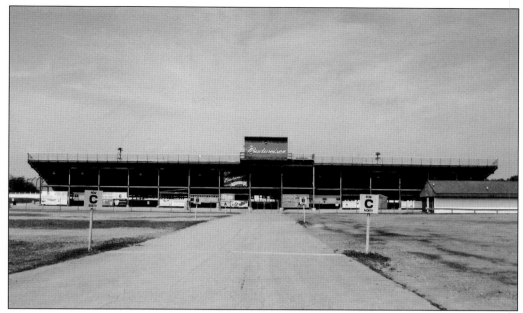

FLAT ROCK SPEEDWAY. In 1952, a revolutionary idea came upon a group of businessmen to build a quarter-mile high banked racetrack where farm fields sat. The project looked like it was doomed to fail before it could begin. Thanks to the rescue by Sheldon Hayes, president of the Cadillac Asphalt Paving Company, the project proceeded. Hayes saw that no expenses were spared and supplied the racetrack with everything it needed. Most notable was the revolutionary track created out of 70 tons of rubber mixed with asphalt, creating the country's first "rubberized" asphalt surface. One year later, the dream became a reality, and the Flat Rock Speedway opened in 1953. For the past 30 years, this has been the location of the semiannual Flat Rock Historical Society's flea market held in May and October. (Both, Stacey Lee Reynolds.)

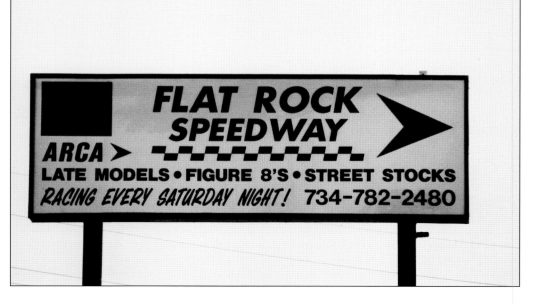

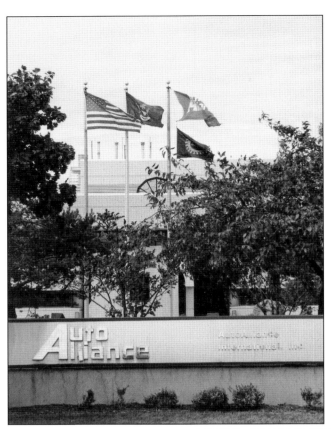

MAZDA AND AUTO ALLIANCE. The plant was built where the Ford Casting Plant was located. The plant began as Mazda Motor Manufacturing. It started with the production of the Mazda MX-6 on September 1, 1987, followed by the Ford Probe in January 1988 and the Mazda 626 sedan in September 1989. In 1992, Ford partnered with Mazda to form Auto Alliance International. Production of the Ford Mustang began here in 2005. (Both, Stacey Lee Reynolds.)

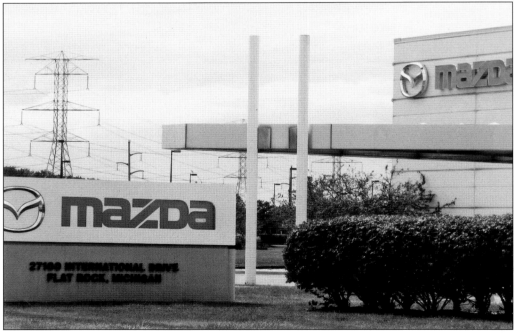

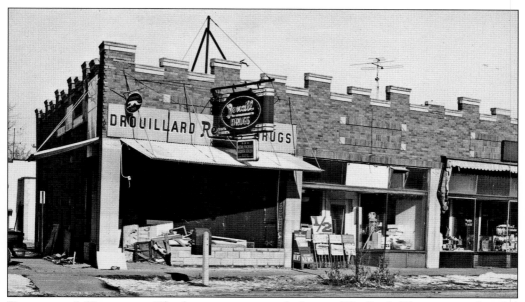

DROUILLARD'S DRUGSTORE. The drugstore was once the heart of Flat Rock. The store was founded by Joseph Drouillard on Telegraph Road and Erie Street, across from the Smith Hotel. It was the headquarters for the bus depot, payment of utilities, and many other services. The store was destroyed by fire on April 10, 1962. (Bodary family.)

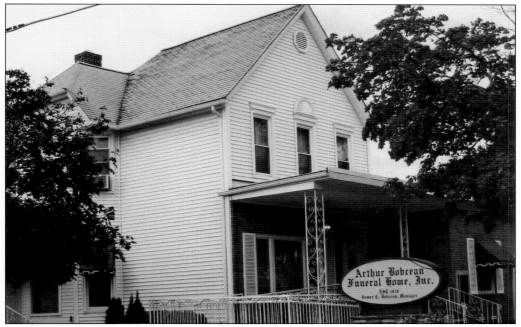

ARTHUR BOBCEAN FUNERAL HOME. The Arthur Bobcean Funeral Home is a family owned business that has served families since 1939. Arthur joined the undertaker business with his father, Edward H. Bobcean, in 1934. In 1939, Arthur and his wife, Ethel, moved to Flat Rock and started their funeral home where it remains located today, at 26307 East Huron River Drive. (Author's collection.)

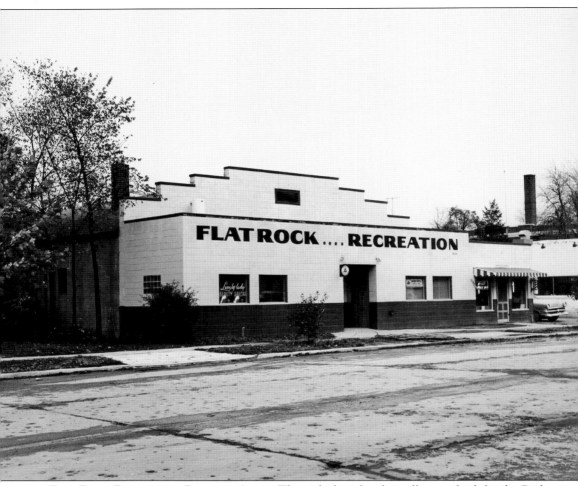

FLAT ROCK RECREATION BOWLING ALLEY. The eight-lane bowling alley was built by the Bodary Builders crew in 1939 and managed by Gene Littler. Pinsetters were responsible for setting the pins after each frame bowled. In 1957, the first automatic pinsetters were installed. A spotter sat at the foul box located at lane one, and bowlers had to listen to make sure a foul was not called out against them for crossing the line. (Bodary family.)

Three

AROUND TOWN

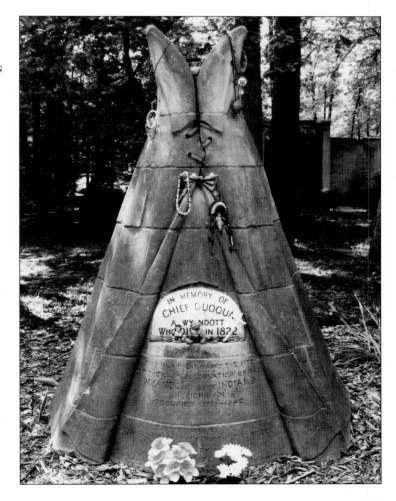

CHIEF QUAQUA TEEPEE MEMORIAL IN MICHIGAN MEMORIAL CEMETERY. The inscription reads: "This monument marks the site of the last reservation of the Wyandot tribe of Indians in Michigan. Occupied 1818-1842." The Chief Quaqua monument was erected to memorialize the existence of the Wyandotte Reservation and the Indian tribe that once lived there. The headstone of Chief Quaqua is embedded in the concrete of the Wyandotte Indian monument. The Michigan Memorial Park Cemetery, the City of Wyandotte, and the Huron-Clinton Metropolitan Authority restored the original monument and moved it to the cemetery. (Author's collection.)

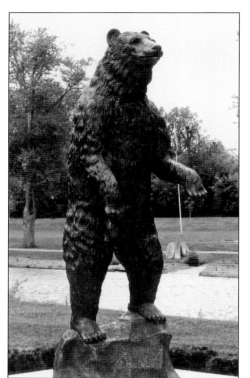

MUKWA. The 7-foot tall, black granite monument is located on Arsenal Road near the youth center and the entrance to Huroc Park. The marker reads, "This area was the home of the Indian tribe known as the Wyandot. They fished in these waters for burbot, sturgeon, and walleye. The bear represents both strength and a healing spirit. The bear is known as the Mukwa to Native people in this region. One of the twelve clans of the Wyandot was the Bear Clan. They alone could wear the bears' claws, teeth, and necklaces of the Mukwa." (Author's collection.)

BUFFALO HIDE. According to the Southeastern Michigan Historical Bison Reserve and Habitat, authentic records show buffalo were in Wayne and Monroe Counties. However, these great animals disappeared from Michigan near the end of the 1800s. The last recorded buffalo was thought to have been killed in December 1822, at the crossroads of Sibley and Allen Roads, by the owner of the land, J. G. Carson. The hide of this 2,000-pound animal is on display at the Flat Rock Historical Museum. (Author's collection.)

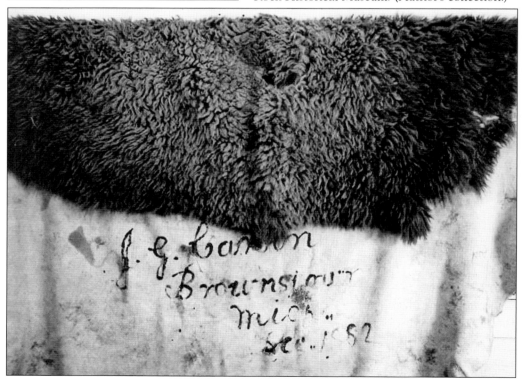

HUROC PARK. The park totals 27.42 acres and was purchased in two transactions. In 1949, there were 6.62 acres bought for $500, and in 1950 there were 20.8 acres purchased from Ford Motor Company for $2,000. In October 1960, the Flat Rock Rotary Club dedicated the youth center, which was built from donations and with minimal cost. The Kiwanis Club provided the landscaping for the center. Many improvements have been made to the park over the years.

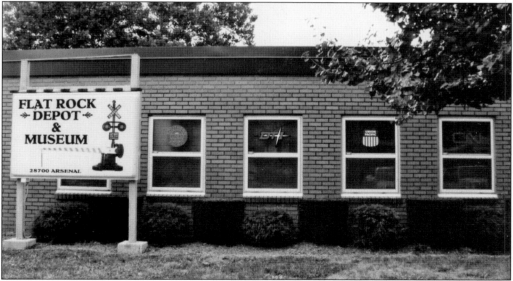

FLAT ROCK DEPOT AND MUSEUM. Located in the former youth center at Huroc Park, the museum is sponsored by the Flat Rock Model Train Club. They are dedicated to the preservation of the history of railroads in the area. The railroad lines, dam, and Model T Headlamp Plant are displayed to scale on the layout inside. Additional information about the Detroit, Toledo, and Ironton (DT&I) railroad story can be found inside. (Author's collection.)

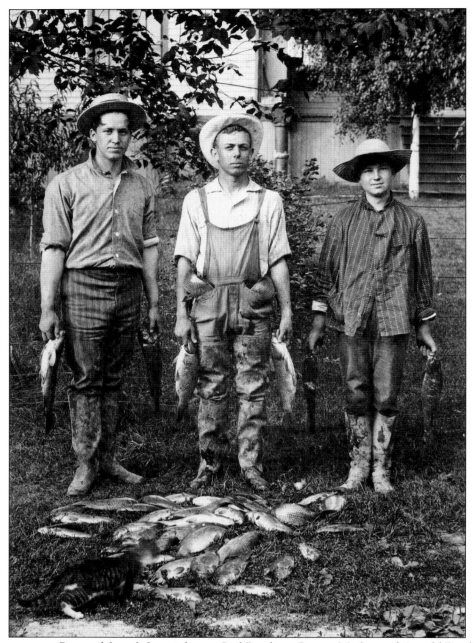

FRESH CATCH. Pictured from left to right are Carl Reading, Carson Metler, and Arnold Reading. Huron River was chock-full of fish. The boys from town were frequently seen fishing at the river, where it was a common sight to see large sturgeon heaped up on the riverbanks where they had been speared the night before. They were usually given away or sold for a small price to anyone who wanted them. In 1897, Freeland Garretson wrote the adventure of Edward Clarke and a sturgeon: "Edward saw a large sturgeon swimming down a shallow stream, jumped astride it, and after putting up a good fight, got his hands in the gills and landed the fish. The fish measured over 6 feet, and the adventure was the talk of the village for quite some time afterwards."

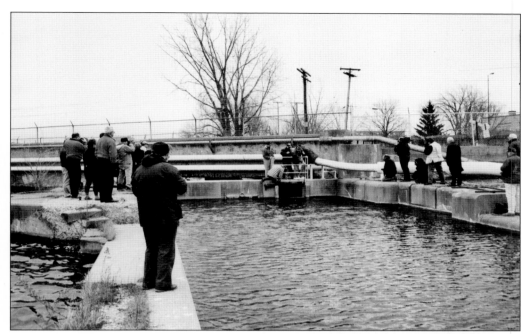

GATE OPENING (ABOVE) AND FISH LADDER (RIGHT). The fish ladder was built by the fund-raising efforts of volunteers and in conjunction with the Michigan Department of Natural Resources. The ladder allows steelhead fish to swim further up the river and spawn. There were two steelhead plantings of 60,000 fish each in 1997 and 1998. Due to these plantings, steelheads have been found spawning upstream. The ladder won the conservation project of the year in 1997 from the Michigan United Conservation Club. At the gate are Earl Kaiser, Chuck Raymond, Rick McKeith, Loren Bennett, Mick Millcan, and Larry Belville along with photographs for local newspapers. (Above, Ron Klingel; right, George Younglove.)

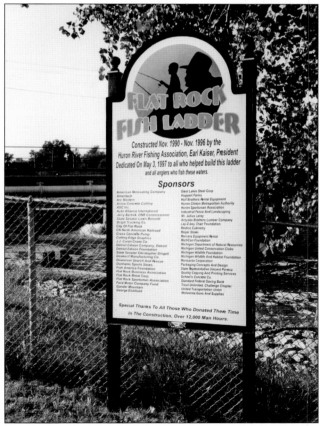

Flat Rock High School,

✻Annual ✻ Commencement ✻

Friday Evening June 19, 1896,

—— AT ——

LOBDELL'S OPERA HOUSE,

Baccalaureate Address at the M. E. Church,

Sunday Eve., June 21,

By Rev. Charles Simpson.

CLASS OF '96.

Motto: " PUSH FORWARD." Emblem: FLEUR-DE-LIS.

FRED C. FISCHER, *EMMA D. McCARTER,*

R. FRANK RICHARDS.

PROGRAM.

Chorus, "The Red Scarf,"	*Theo. Bonheur*
Invocation,	*Rev. C. SIMPSON*
Chorus, "O'er The Waters,"	*C. E. Rowley*
Oration, "The Use of Electricity,"	*R. FRANK RICHARDS*
Recitation, "The Duel,"	*FREDDIE WALTERS*
Essay, "The Advantages of a Good Education,"	*EMMA D. McCARTER*
Recitation, "Liberty and Independence,"	*MOREY COCHRAN*
Oration, "Labor and Wealth,"	*FRED C. FISCHER*
Address, "Horace Mann, the Educator,"	*J. E. HAMMOND*
Presentation of Diplomas,	*Rev. H. O. PARKER*
Drill,	*GRAMMAR DEPARTMENT*
Chorus, *(a) "On the Sea,"*	*G. Donizetti*
(b) "The Merry Farmer Boy,"	*Geo. F. Wilson*

Music conducted by Mrs. Louise Mettler-Smith, Special Teacher.

Admission, 10 Cents. Reserved Seats, 15 Cents.

THE OPERA HOUSE. The Flat Rock Opera House was built by Dr. John Lobdell around 1874. It became known as the Lobdell Opera House. The building was built of wide white pine boards with strips of narrow wood, similar to the Munger Museum. The Opera House was once the hub of entertainment for the town—the building hosted roller-skating parties, graduation ceremonies (as evidenced by the class of 1896 commencement announcement shown here), and receptions. About 1887, the building was sold to the Grand Army of the Republic and was moved in two parts to the corner of East Huron River Drive and Seminary Street, which is Garden Boulevard today.

Blackfaced women with a guitar and clock (1900). The girls in the picture were born in the early 1880s and were participating in a school musical. Pictured are, from left to right, (first row) Mrs. Discher; (second row) Martha (Niefert) Broughton and Myrtle Julian Olmstead; (third row) Louise Kieken, Susie Thompson, and Celica Niefert.

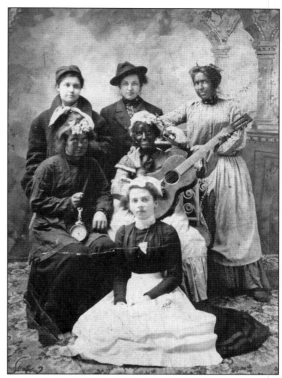

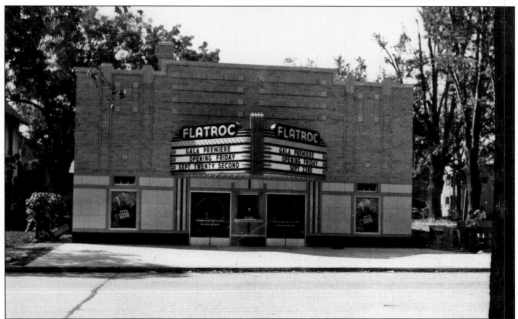

Flat Rock Theater. The grand opening on September 22, 1939, featured the movie *Five Came Back* starring Lucille Ball and Chester Morris. In 1939, if you visited the theater on Tuesday the admission for a child was 5¢ and adult admission was 15¢. The shows changed every Tuesday, Friday, and Sunday. The theater closed around 1965.

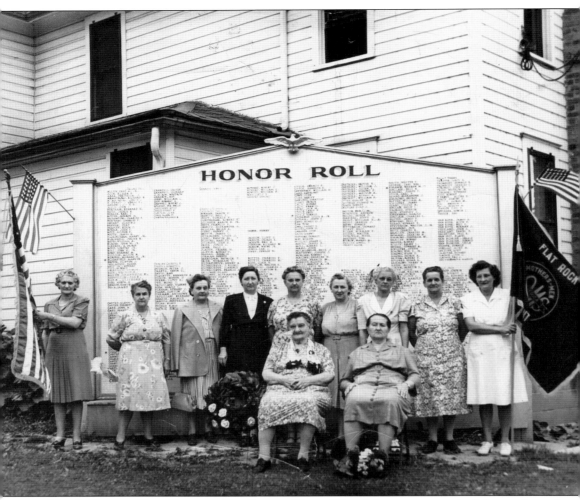

Mom's Club of Flat Rock by Old Legion Hall. The club was composed of the mothers of veterans. From left to right are (first row) Elizabeth Diekman and Katherine Mathews; (second row) Edna (Flag) Hood, Edith (Watson) Hoeft, Irene Cornwell, Emma Oestrike, Elizabeth Broughton, Mrs. Bick, Martha Mathias, Carrie Van Riper, and Marie Burgess.

GRANGE MEETING, 1950. This image is believed to have been taken at Edith Wagar's home on Briar Hill Road during a Grange meeting. This is an organization for American farmers that encourages farm families to band together for common economic and political well-being. Included in the picture are (first row) Lena Taylor, Edith Wagar, and Sadie Lobdell; (second row) Edith Ferstle and Ada Wagar.

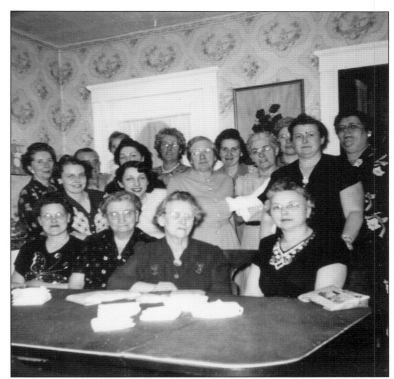

WAYNE COUNTY SELECTIVE SERVICES BOARD NO. 63. The board was located in the Ford Auto Dealership at 28417 North Telegraph Road and Moses Street during the fall of 1942 (where the current Monroe Bank and Trust is located). From left to right are (first row) Betty (Mathews) Payne, Helen (Kovacek) Berakovich, and chief clerk Katherine (Kovacek) Stopa; (second row) Margaret (Gay) Charlesworth, Verlinda (Chinavare) Lezotte, and assistant clerk Gertrude (Neimeyer) Fleming.

FLAT ROCK COMMUNITY CENTER. Located near I-75, off of Gibraltar Road and nestled into a 27-acre wooded area, sits the 50,000-square-foot community center. According to *Connecting with Downriver: Corporate Citizenship Report*, the center was built with funding from Auto Alliance and the sale of Tax Increment Financing Authority bonds. Designed to preserve the natural feel of the site, the building is made with wood, fieldstone, and cast stone. The building, roads, and parking lots were designed to protect the wetlands. The center includes meeting and banquet facilities, a pool with slide, gymnasium, weight and fitness area, running track, and a kitchen. The grand opening of the building occurred on January 8, 2005. (Both, Stacey Lee Reynolds.)

FIRST BANK OF FLAT ROCK. At the time of this photograph, taken May 30, 1911 or 1912, the officers of the bank were president Delbert W. Powers, vice president James W. Losee, and cashier Guerd M. Retan. The bank was located adjacent to Morey's Department Store on East Huron River Drive. The bank is presumed to have opened in 1902 with a capital of $5,000.

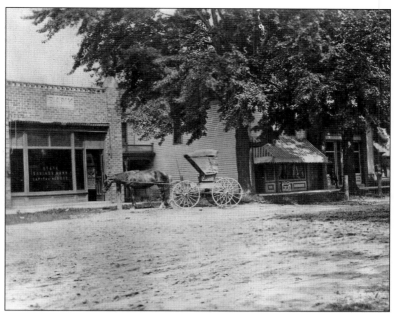

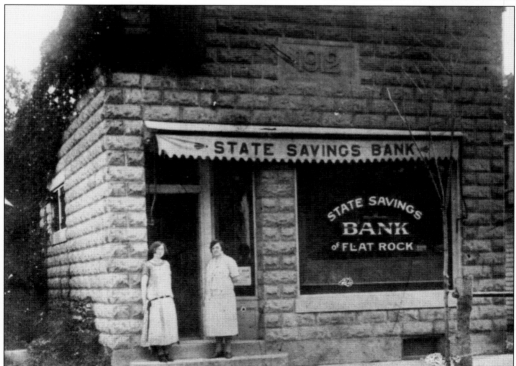

STATE SAVINGS BANK, C. 1912. Hilda Case (left, b. 1896) and Stella Ernst (b. 1885) are standing in front of the bank. On October 26, 1911, six men from Flat Rock organized the bank originally located in a building they owned on East Huron River Drive. On March 4, 1912, the bank opened for business. The founders of the bank were Curtis L. Metler, J. Forrest Lindsay, Frank S. Peters, George H. Brandes, Morey D. Cochran, and Julius Neifert.

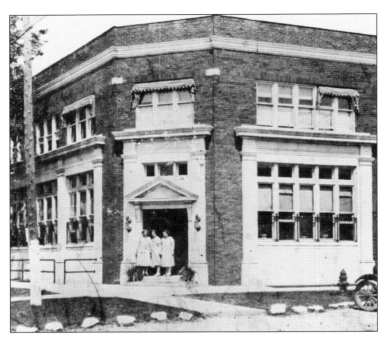

STATE SAVINGS BANK. In 1926, the bank moved into a new building on the corner of Telegraph Road and East Huron River Drive. There were offices upstairs and five rooms in the basement. The basement had a barbershop and beauty parlor in it. In March 1929, the library was moved here. The bank closed its doors on July 1, 1931, and it was placed in the hands of a receiver, Walter C. Strum, the Michigan State Commissioner of Banking.

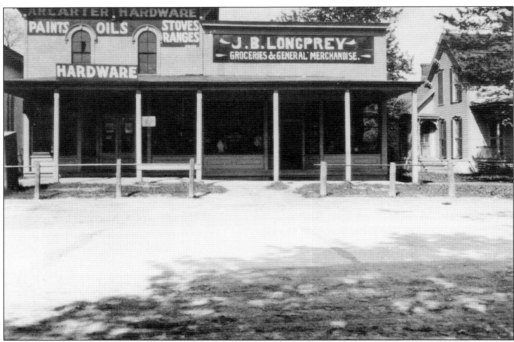

J. B. LONGPREY GROCERY AND HARDWARE. The store was located on East Huron River Drive. The first library collection for the village of Flat Rock was placed here. In 1921, Julia Longprey volunteered her services, and the first Flat Rock Library was established. In the store, 154 books were placed on a crowded counter. The collection was mainly used by the high school students and 28 registered patrons.

LIBRARY IN THE BASEMENT. The exterior image shows the stairway entrance located on the left side of the Flat Rock State Bank leading down to the basement. The library was located here during the 1930s and 1940s. The collection grew to 2,600 items and had 800 registered patrons, including participants of the Women's Club and Boy Scouts organizations.

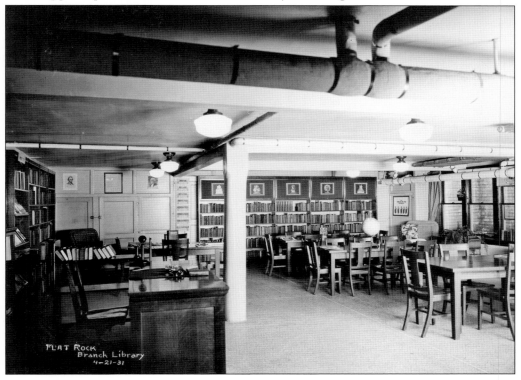

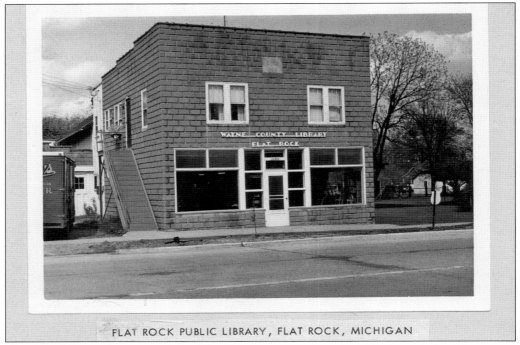

FLAT ROCK PUBLIC LIBRARY, FLAT ROCK, MICHIGAN

FLAT ROCK PUBLIC LIBRARY, 1950s. The library was moved in the 1950s from the bank basement to this building owned by and located behind the Smith Hotel. The building was originally built by Oscar Smith as a furniture store. Later Mel Oestrike had his insurance office in the building. It was destroyed by fire in 1991.

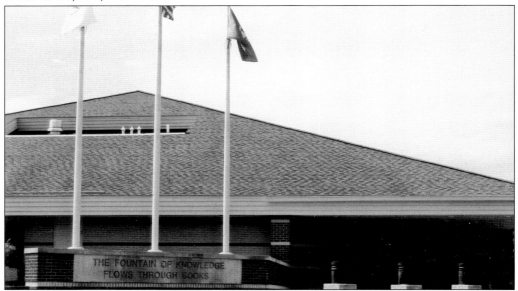

FLAT ROCK PUBLIC LIBRARY, 1999. The library motto, "the fountain of knowledge flows through books," is shown in this image. The current library is located on Gibraltar Road. The library houses over 36,000 books and serves approximately 12,000 patrons. In addition to offering books, the public library hosts many classes and events. (Author's collection.)

"COPPER" ARTHUR A. BUSICK, 1930S. A *Guardian* newspaper article dated October 5, 1939, states that with the backing of the Federal Bureau of Investigation, Busick completed a 12-week course at the National Police Academy. Upon his completion and arrival back to Flat Rock, Busick announced his plans to start a local school to train both police and firemen in first aid work. The man in front is Ransford Button.

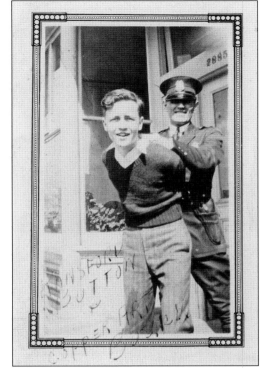

ARTHUR A. BUSICK. This image shows Busick on Telegraph Road in front of the police station. The horse was owned by George McTaggert and the buggy was owned by Robert Oestrike. In the background, the Iron Horse Diner and the Flat Rock Mill are visible. The diner was located on the southwest corner of Telegraph Road and Arsenal Road, where the Dairy Queen is currently located.

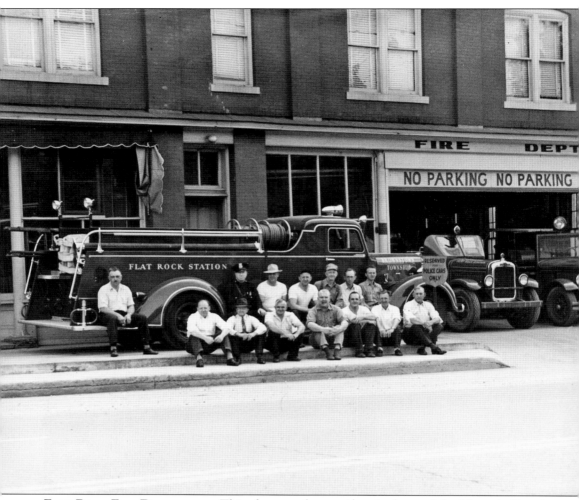

FLAT ROCK FIRE DEPARTMENT. This photograph was taken in front of the Masonic Temple, which housed the fire department. Originally organized in the early 1920s, the fire department purchased its first new fire engine, a 1927 American LaFrance. The firefighting equipment was stored in Walter Wright's Chevrolet dealership. All incoming calls were answered at the police station, a siren was set off, and the firefighters reported to the station to get the equipment. The fire department was originally responsible for covering the 36 square miles of Brownstown Township, including the villages of Flat Rock, Rockwood, Gibraltar, and Woodhaven. In 1956, Brownstown Township decided each village was responsible for their own protection.

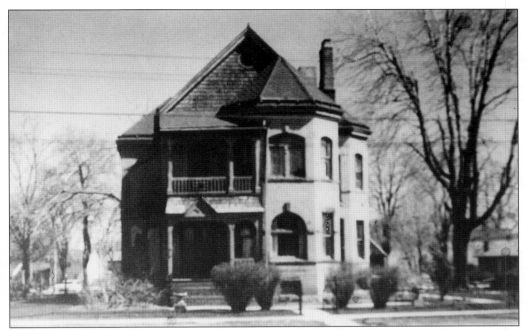

COCHRAN'S HOME. W. S. Morey built this home for his daughter Carrie when she married W. D. Cochran. This brick mansion was built in 1880 and was located on Telegraph Road, between Huron River Drive and Erie Street. It was demolished in 1964 to make room for a parking lot. Carrie's sister, Alice, was married to Dr. John H. Lobdell.

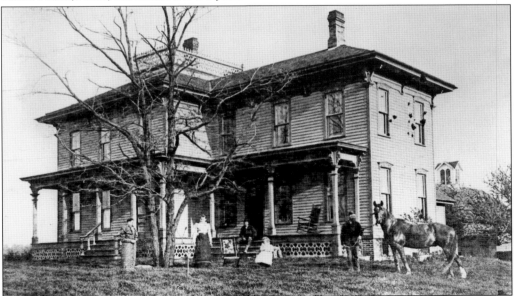

LOBDELL HOUSE ON WILL CARLETON ROAD. Dr. John H. Lobdell (January 14, 1860–September 28, 1931) was part of the first graduating class from Flat Rock High School. He studied medicine at the University of Michigan and at the Detroit College of Medicine, from which he graduated in 1881. He married Alice M. Morey on November 2, 1880, and they celebrated their golden anniversary in 1930.

CASE FARM, 1811 LOCUST HILL. The farm was located behind the state post office and is believed to have originally been built by the Vreelands. Daniel C. Vreeland bought 130 acres just south of the Huron River from his father, Michael Vreeland, in 1834 and built this house on it. He moved into it from his log cabin across the river in 1836. Michael Vreeland is believed to have died here in 1841 and Daniel in 1855. George Case bought the property in 1908 and added the grand porch around 1920. (Don Fesko.)

METLER HOUSE WITH ERIE CANAL (IN BACKGROUND). The Gibraltar and Flat Rock Company was organized July 20, 1836. The company was incorporated for the purpose of building a canal at the mouth of the Huron River, connecting in Flat Rock and onwards through Ann Arbor, Jackson, Kalamazoo, and eventually to Lake Michigan. Hundreds of Irish diggers were relocated to the area by the Gibraltar and Flat Rock Land Company. Working with wheelbarrows and shovels, they set out to dig the canal. About 3 miles of the canal were completed when the Wildcat bank panic hit Michigan in 1838. By 1843, the effort to build the canal died. Most of the canal has been filled in over the years, but traces of the canal can still be found in Flat Rock.

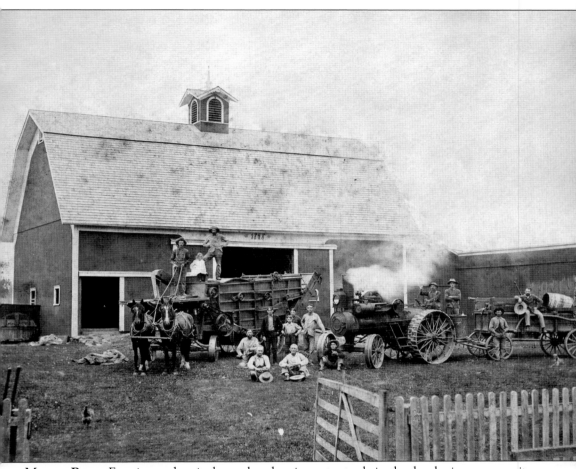

METLER BARN. Farming and agriculture played an important role in the developing community. This scene shows unidentified people sitting in front of the family barn. It is believed this was located behind the Metler House.

DAVE WALLACE HOUSE. This house was built in 1880. Successive owners after Dave Wallace were the Cranes, the Moses, Holts, and it was eventually left to the Parson family. During the 1940s, it was used as a restaurant. In 1969, the house was razed and a Kinney Shoe store was built there. (Gloria Dunn.)

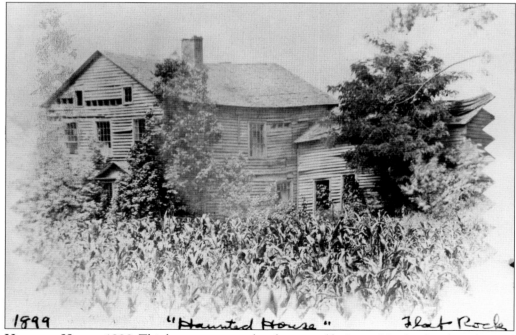

HAUNTED HOUSE, 1899. This home was owned and occupied by James Vreeland and was located on East Huron River Road.

VAUGHN HOUSE, 26255 HURON RIVER DRIVE. This is an example of Victorian Gothic architecture. This is a two-story, L-shaped gabled house with clapboard siding, windows, and portico. It is topped by a second-story balcony with stick work on bargeboards and balustrade. The home was originally constructed in 1884, and the first owner was Chesley Hitchcock. (Author's collection.)

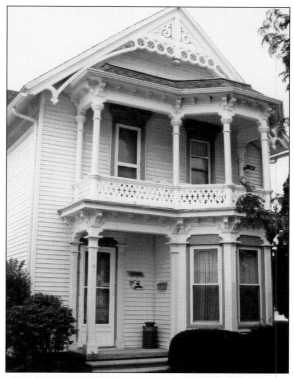

HIRAM LOBDELL HOUSE, 26131 HURON RIVER DRIVE. There are two types of Greek Revival architecture. This home is an example of the more modest style. This was a popular style featuring a symmetrical rectangular shape, low roof lines, pediments, and few embellishments. (Author's collection.)

THE METTLER HOME AT 28911 SENECA STREET. This home is an example of Greek Revival architecture. It is a two-story with a standing seam truncated hip roof with two large offset chimneys. There is a large wraparound porch supported by Doric columns, with a balustrade with Doric column balusters. (Author's collection.)

CAPT. JOHN WELLES HOUSE, 23815 GIBRALTAR ROAD. This home is an example of an Italianate farmhouse. The Captain John Welles house was built in 1872. This Italianate farmhouse is a large two-story home with heavily carved and detailed brackets, porches, bay windows, red brick veneer accented by drip moldings at window heads, decorative brickwork, and corbelling. While it is an attractive dwelling, the structure is of significant importance. As a frame house, it was built with a heavy mortise and tenon barn-type frame and sheathed in brick veneer. (Author's collection.)

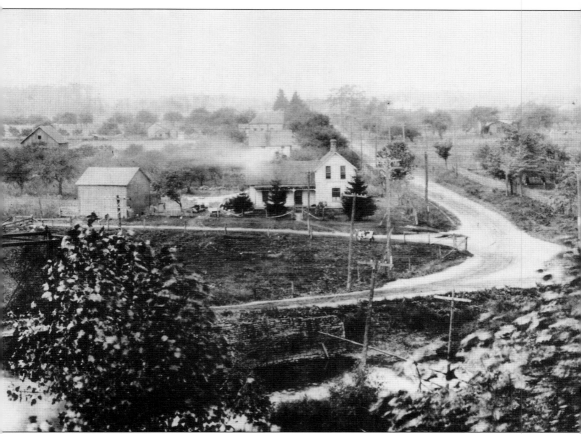

DIEKMAN FARM. This photograph shows the view of Telegraph Road traveling south into Monroe County from the river. An old metal bridge is pictured. When the first cement bridge was built, it was constructed to the west of the metal bridge. The metal bridge was taken down in the 1920s. The road to the east is the present-day South Huron River Drive. The farm belonged to Joseph Diekman and was moved three times in order to straighten Telegraph Road. This picture was taken by Andrew Reading from the top of the Flat Rock Mill.

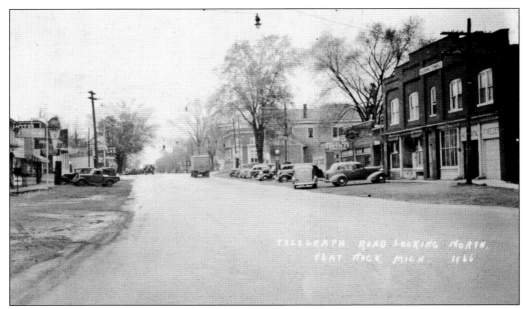

Telegraph Road looking north, 1966. This postcard shows the Alfred Burden Building (blacksmithing and wagon making), which was built in the 1890s. The city police department and hall where the Masons met is shown. Dr. Hasley's house and office and the bank are pictured on the far right.

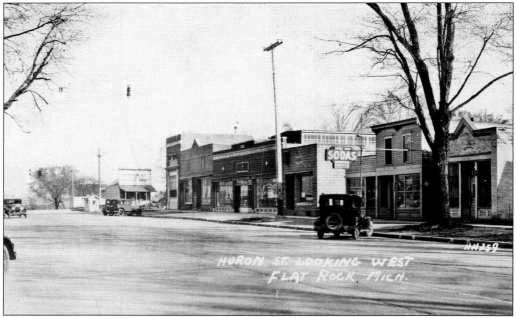

East Huron Street looking west. This postcard shows George Beaufien's Barbershop, Limbrights Clock and Jewelry Store, telephone office, candy store, Bunte's store, and the bank. Ed Munger's general store can be seen across Telegraph Road on the corner.

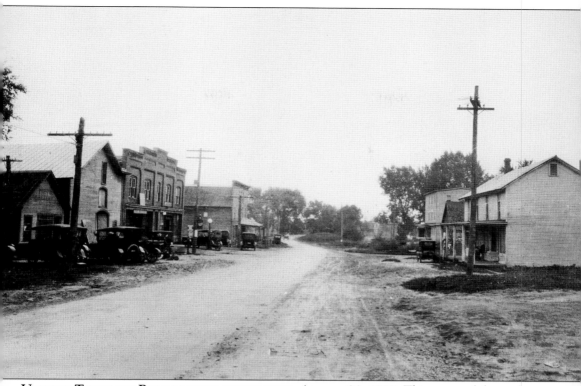

Unpaved Telegraph Road looking southbound, August 30, 1922. This postcard shows the Masonic Temple on the left, which housed the police and fire department on the main floor. The mill can be seen the furthest away on the right. This penny postcard was mailed to Emma Knock in Detroit from Mr. and Mrs. Kelly.

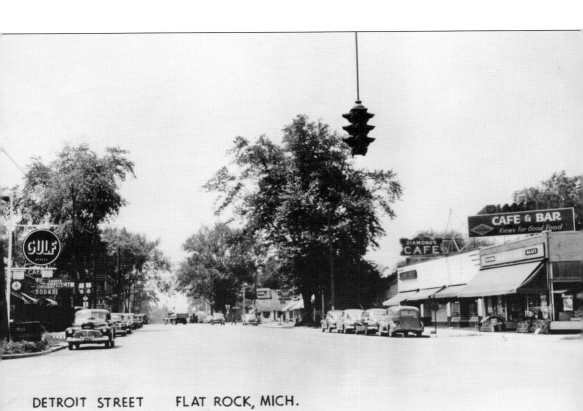

DETROIT STREET FLAT ROCK, MICH.

TELEGRAPH ROAD/DETROIT STREET. In 1847, Gov. Epaphroditus Ransom believed plank roads could greatly benefit communities. He signed for a plank road to be built through Flat Rock, and this road was known as Telegraph Road. These roads were originally made of oak planks laid crosswise on stringers or directly on the ground. Over time, warping and rotting planks made it dangerous for the horses to trot upon. Telegraph Road (US-24), also known as Detroit Street, was originally the only road running through Flat Rock, between Dearborn and Monroe. The road was named for the telegraph lines running alongside the road.

Four

CHURCHES, SCHOOLS, AND SPORTS

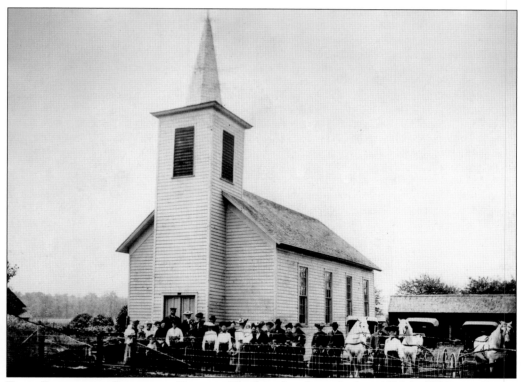

FAITH EVANGELICAL LUTHERAN CHURCH. The first church was built in 1890 for $700 on a 10-acre site located on Arsenal Road, south of Van Horn Road. This one-room structure with a steeple was constructed with native Michigan lumber and was originally named Jehovah Lutheran Church to serve the devout German farmers in the area. The church has continued to expand and evolve to meet the needs of the congregation and recently celebrated its 100-year anniversary.

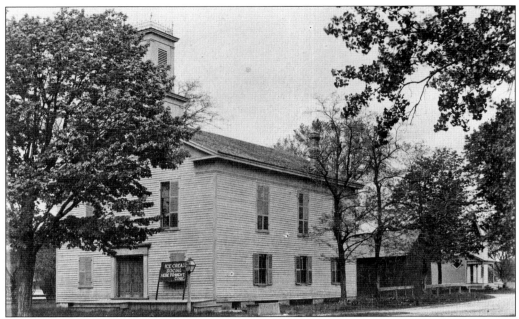

METHODIST CHURCH, 1852–1902. In December 1823, Rev. James Finley, a Methodist preacher, came to preach to the Wyandot Indians. Soon after, a church was organized by 12 individuals. Initially both American Indians and white settlers joined the congregation, and a small log church was constructed. Eventually the Native Americans were relocated out of the area, yet the church continued to grow and a 30-by-30-foot structure was built on Huron River Drive. In 1852, a much larger and ostentatious church was erected. This church continued to prosper until 1902, when this building was removed and replaced with another. The church remained on Huron River Drive for the next 59 years. As the congregation continued to grow, it was decided that a new church was to be built. Land was donated on Evergreen Street, and the ground was broken on March 12, 1961, for the new site. The church currently remains at the site on Evergreen Street and continues to serve the community and congregation. (Below, Stacey Lee Reynolds.)

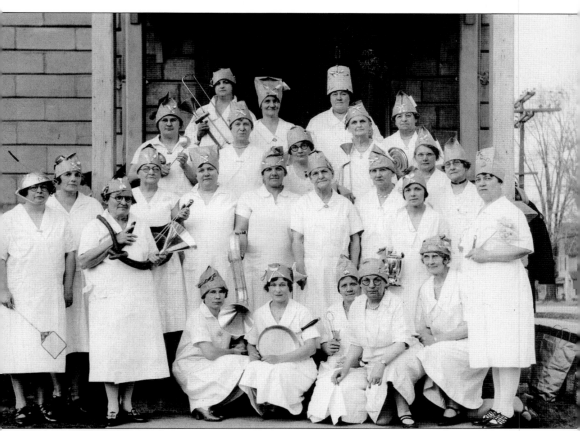

THE 1933 METHODIST CHURCH KITCHEN CABINET ORCHESTRA. Members are, from left to right, (first row) Katherine Finley, Mable Sieben, Ada Carter, Jennie Ingurole, Orpha McBain, and Anna Lindsey; (second row) Fannie Harrington and Nellie Crooks; (third row) Della Stoflet, Annie Johnson, four unidentified, Grace Brown, and Georgina Cornwell; (fourth row) Mae Bunte, unidentified, Myra Taylor, Lydia Neifert, and Mrs. Alfred Carter; (fifth row) Elva Machis, Carrie Hammond, and Catharine Crooks.

First Congregational Church. Established as a Presbyterian church in 1832 by Peleg F. Clark, this is one of the older churches in the area. The church died out in 1856, but original Presbyterian members joined other town folk and organized a Congregational church in 1858. Mr. and Mrs. Romeyn B. Murray donated land on East Huron River Drive on September 20, 1860, for the purpose of building the church. The surrounding residents were cash poor but provided "a stick of timber" and offered their labor to assist building the new house of worship. The main building is the same as when it was first constructed. The building was square with a wide front door in front, opening into a vestibule, from which two doors, one on each side, entered into the sanctuary. The church recently celebrated its 150th anniversary in 2008.

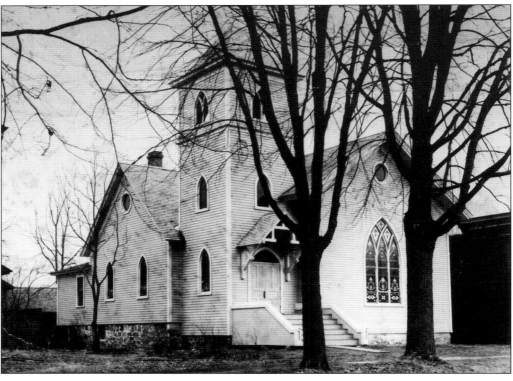

SUNDAY SCHOOL CLASS OF THE CONGREGATIONAL CHURCH. Pictured are, from left to right, (first row) Reverend Hutchinson, Lucille Richards, Josephine Livernois, Mae Oestrike, Sarah Jane Bailey, Betty Price, Fern Van Riper, Alice Brestow, Shirley Watson, and Mabel Semnick; (second row) Betty Hutchinson, Della Kaiser, Marion Peters, unidentified, Jean Ropecki, Mary Ropecki, and Nellie Franchak; (third row) Bertha Oestrike, Doris Neid, Alma Brick, Jean Sampson, Leona Hoeft, Marie Chase, Winnie Oestrike, and ? Kaiser.

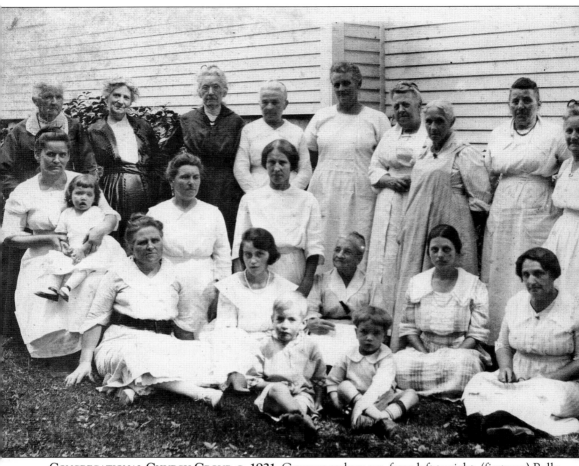

CONGREGATIONAL CHURCH GROUP, C. 1921. Group members are, from left to right, (first row) Bella Pinck, Lila Rice Parsons, Mary Stoflet, Helen Lambe Hitchins, and Cora Pierson; (second row) Carrie Van Riper (holding Fern Van Riper), Mamie Van Riper, and Mable Bunte. Included in the third row are Meltha Stoflet, Nettie Jubenville, Charlotte Collins, Emeline Near, Susan Thompson, Mary Lambe, and Lillie DeLong. The children are Forest Bunte and James Van Riper.

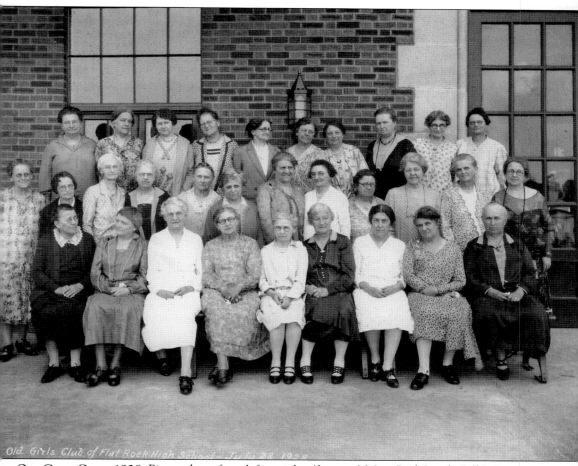

Old Girls Club of Flat Rock High School — July 28 1928

OLD GIRLS CLUB, 1928. Pictured are, from left to right, (first row) Mary Pink Lamb, Billie Gravit Moor, Carrie Thorn Carter, Eliza Hosmer Lathrop, Nellie Donivan Olmstead, Emma Peters Dauncey, Libbie Jones, Jennie Lautenschlager Crook, and Jessie Pierson; (second row) Clara Peters Todd, Leona Pierson Vreeland, Mina Smith Chamberlin, Flora Donavan Baxter, Rachael Wilton Carter, Susie Langs, Gertie Edwards Wagar, Edith Hall Monroe, Mary Lautenschlager Near, Ella Wood, Lyda Carter Neifer, and Mary Hoope Grigler. Included in the third row are Edith Smithson Wagar, Edith Harryman Clark, Susie Olmstead Burton, Bille Chapin Pink, Mary Turner Louis, Celaia Gordon Garretson, Jennie Hall Ingersal, and Mary Pierson Fisher.

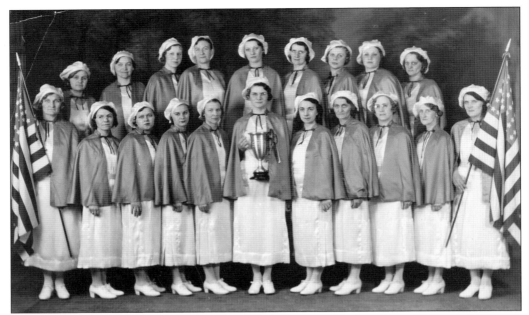

DRILL TEAM OF SILVER STAR COUNCIL NO. 22. The drill team tied for first place with Goodwill Council No. 19 in the competitive drill held in Michigan, November 14, 1935. This team photograph appeared in the February 1936 issue of *Daughters of America* magazine. (Gloria Burgess Dunne collection.)

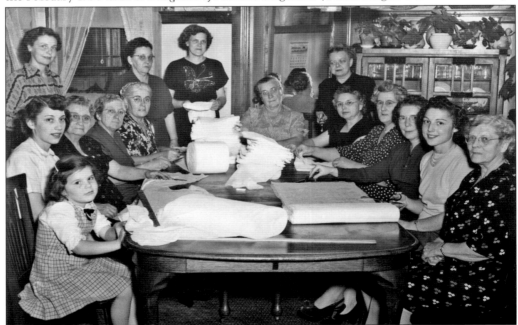

RED CROSS VOLUNTEERS. Gathered at Edith Wagar's home, the group was working on making cancer pads this day in 1950. From left to right are Kathy Stumpmeier, Kathleen King, Edith Wagar, Edith Ferstle, Kay Stumpmeier, Adah Wagar, Ruth Parker, Florence Esther Baker, Kate Stumpmeier, Mrs. D. Barker, Delilah King, Mrs. Hobbs, Ollie Robinson, Jean King, and Emma Wagar (Mrs. Williams).

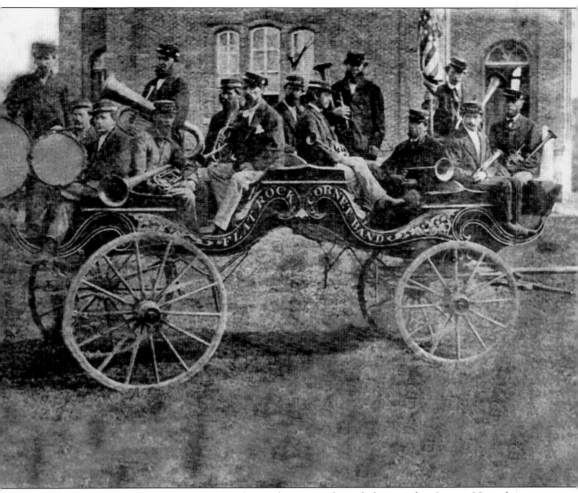

FLAT ROCK CORNET BAND, 1873. Band members are, from left to right, James Harndon, unidentified, John Vincent, Osmand Harryman, unidentified, Thomas D. Cooke, Dan Mettler, Garry Garretson, Edwin Ransom, Henry Lawrence, S. S. Potter, unidentified, Frank Blakely, and Willet S. Morey.

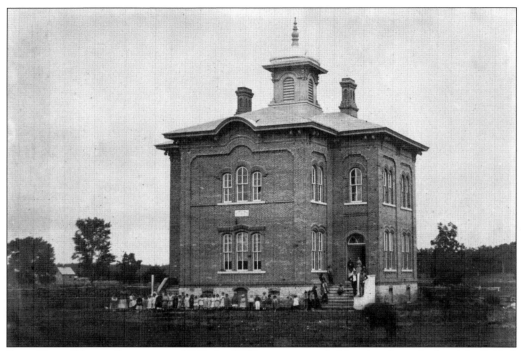

FLAT ROCK UNION SCHOOL, C. 1875. In 1867, a two-story brick school was built with divided halls and schoolrooms—girls on one side, boys on the other. The first graduating class in 1878 contained two students: (Dr.) Orion J. Fay and Alice (Morey) Lobdell. (Dr.) John N. Lobdell graduated in 1879. The early graduation ceremonies were held at the Lobdell Opera House.

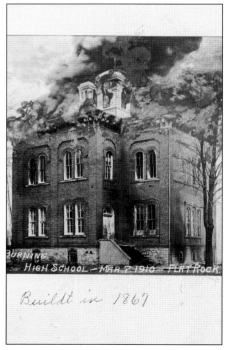

BURNING HIGH SCHOOL, MARCH 7, 1910. In March 1910, sparks from the furnace started a fire in the belfry, and all 150 students were evacuated safely. There was no fire department in Flat Rock at this time, so the school burned to the ground. A replacement school was built in 1911.

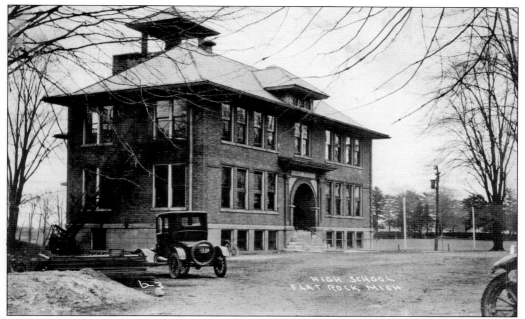

READING BUILDING AFTER BEING RECONSTRUCTED. In 1912, a new, similar brick school was completed on the same site. R. W. Sprinkle was the superintendent and Gertrude Reading was principal. Reading later became superintendent from 1916 to 1925. The name of the school was changed to the Reading School in her honor for many years of teaching and being a leader in education.

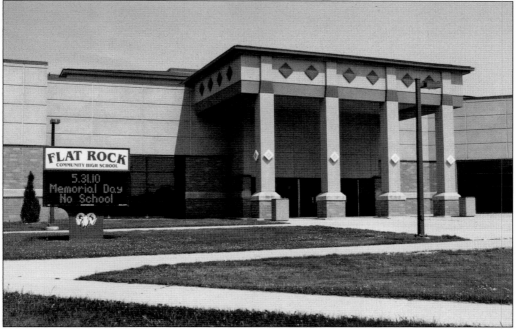

FLAT ROCK COMMUNITY HIGH SCHOOL, 2010. The school is currently located at Seneca and Evergreen Streets and home to the Rams. Recent upgrades include computer labs, industrial arts labs, welding lab, new tiles, updates to the cafeteria, and auditorium lobby. (Author's collection.)

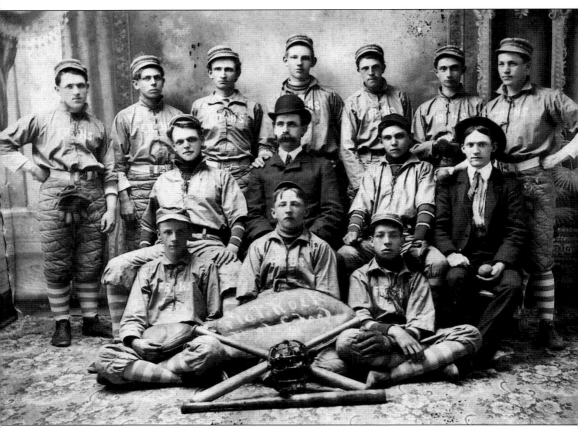

FLAT ROCK BASEBALL TEAM, 1902. Team members are, from left to right, (first row) Henry Wagar, Fred Mathews, and Leo Ferstle; (second row) Morey Cochran, Prof. W. D. Riggs, Don Lobdell, and John Lautenslager; (third row) Harry Reading, Carson Metler, Enoch Chamberlin, Carl Shellenberg, Lee McUaff, Harry Williams, and Carlos Reading.

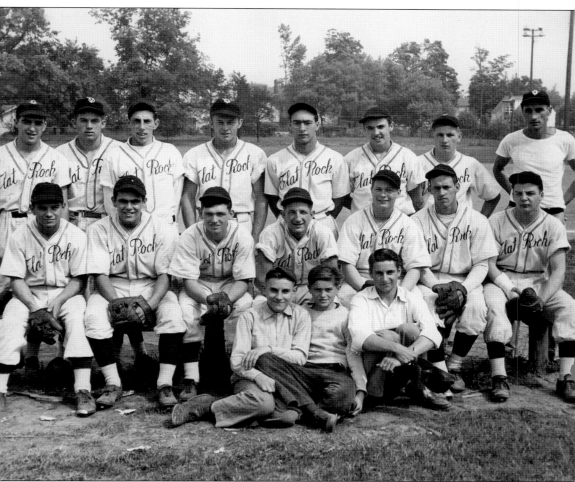

BASEBALL TEAM, 1948. The team's record for 1948 was 15 wins and four loses. The managers are in the first row from left to right: John Livernois, Don Mathews, and Ralph Alexander. Team members are, from left to right, (second row) Eddie Brklacich, Fred Leitas, Bob Norrix, Stub Warner, Hirschell Biggs, Tony Balowski, and Larry Sullivan (captain); (third row) Jerry Flaishans, Don Schweizer, Larry Yost, Orville Pickman, Ernie Labata, Ron Oestrike, Alden Bodary, and Marvin Mittlestat (coach).

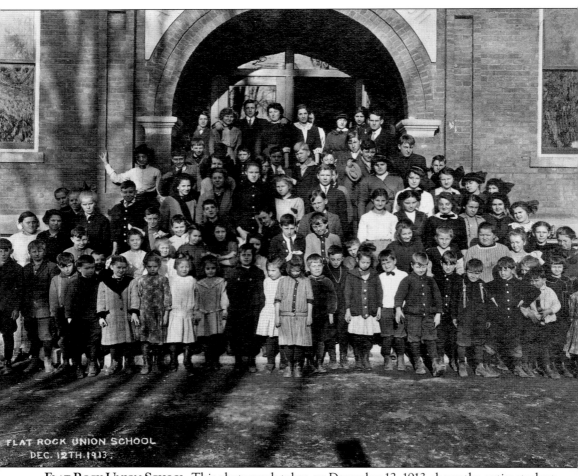

FLAT ROCK UNION SCHOOL. This photograph taken on December 12, 1913, shows the entire student body of the 1912–1913 school year in front of the Reading Building. The Reading Building was named in honor of Gertrude Reading, who was a teacher and principal for many years.

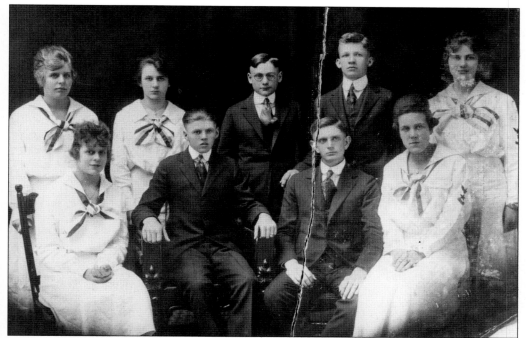

FLAT ROCK HIGH SCHOOL 1918 GRADUATING CLASS. Class members are, from left to right, (first row) Lilah (Smith) Sherer, Earle VanHouton, Fred Hill, and Myrtle (McBroom) Wagar. Among those pictured in the second row are Eunice (Herman) Metcalf, Evelyn (Friedel) Quick, Harvey King, and Mable (Kurtzel) Semneck.

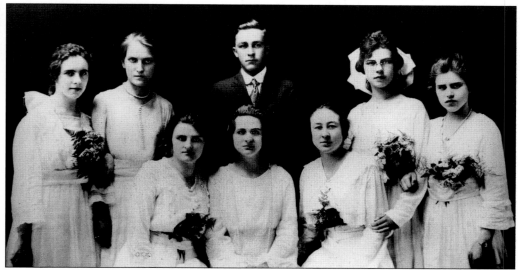

FLAT ROCK HIGH SCHOOL 1919 GRADUATING CLASS. Class members are, from left to right, (first row) two unidentified and Dora M. Rutkowsky; (second row) unidentified, Irlene Tures Kerr, Harvey W. Ernest, Lucile M. Quick, and Aniela B. Jarzynka. From the class roll, it is know that the unidentified students are Frances E. Riedel, Gladys E. Olmstead, and Margaret M. Remn, but their names cannot be placed to the faces. The class motto was, "Tonight we launch, where shall we anchor?"

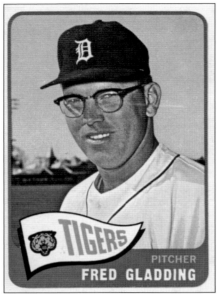

FRED GLADDING. Fred "the Bear" Gladding was the first man from Flat Rock to play in Major League Baseball. Born in 1936, he graduated from Flat Rock High School in 1955. Baseball was his game and the 6-foot-1-inch, 190-pound teenage pitcher was signed by the Detroit Tigers with Coach Mittlestat out of high school. In 1960, he married Margie Clotfelter. By 1961, he was called up to the majors. He started for the Detroit Tigers off and on from 1961 to 1968. He then went to the Houston Astros from 1968 to 1973. (Fred Gladding.)

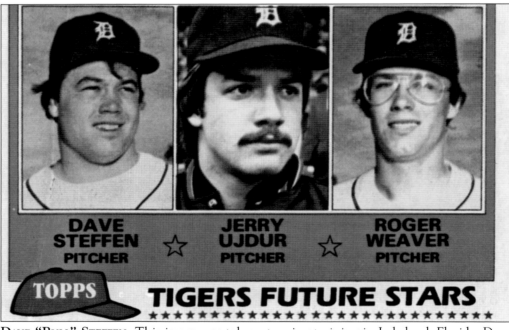

DAVE "BULL" STEFFEN. This image was taken at spring training in Lakeland, Florida. Dave was one of three men from Flat Rock to play for the Detroit Tigers organization. He was born December 17, 1958. Dave graduated from Flat Rock High School in 1977, where he was a three-sport, all-state athlete in football, wrestling, and baseball. The Detroit Tigers drafted him in 1977 as a hard-throwing, right-handed pitcher. While in the Tiger organization, he played for managers Sparky Anderson and Jim Leyland. He was on the big-league roster from 1980 to 1981. In 1982, he signed with the Chicago White Sox organization and reported to spring training under Tony LaRussa. An arm injury ended his career. He married Tammy Stanifer and has twin sons, Casey and Kyle. (Dave Steffen.)

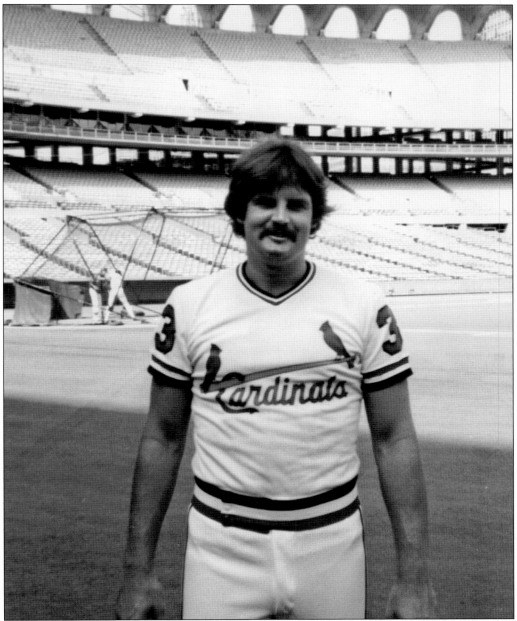

JOHN ROBERT MARTIN. He was born April 11, 1956, in Wyandotte, Michigan. He played varsity football, basketball, and baseball for Flat Rock Community Schools and graduated from Flat Rock High School in 1974. The Detroit Tigers drafted him in 1978 in the 27th round, and after some time in the minor league, he was traded to the St. Louis Cardinals and made his major league debut on August 27, 1980. His best stretch was with the Cardinals in 1981, when he recorded wins against Nolan Ryan and Steve Carlton en route to an eight to five record. John was a member of the 1982 World Champion St. Louis Cardinals team. He was traded to the Detroit Tigers in 1983, and his final major league game was October 2, 1983. His career ERA was 3.94, and his major league record was 17-14 with 120 strikeouts. (John Robert Martin.)

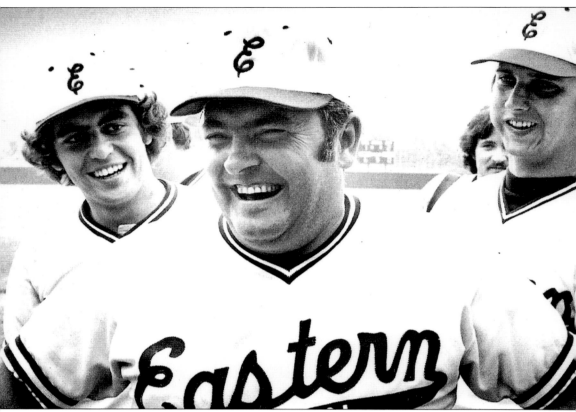

RON OESTRIKE. According to the Spring 2005 *Eastern Educator*, Oestrike graduated in 1950 from Flat Rock High School. He was Eastern Michigan University's head baseball coach for 23 years and credited for turning the baseball program into one of the nation's finest. His career achievements include leading his teams to the 1970 NAIA national title, two NCAA Division 1 World Series appearances, and numerous individual awards, including "Coach of the Year" in 1970. He officially retired in 1998 and was named to the National Baseball Coaches Hall of Fame in 1990. Eastern Michigan University's baseball stadium was officially named Ron Oestrike Stadium on August 26, 1987. (Richard Schwarze.)

Five

NOTABLE NAMES

ELIZABETH (UPHAM) MCWEBB. This house was built by John Cook. Albert Upham bought it from the estate and built an addition on it. George Van Riper bought it from Albert Upham and later it was divided and moved. Half of it is on Van Riper Street and the other half is on Evergreen Street. The people in the picture are members of the Upham family. The baby (in the buggy) is Elizabeth, now known affectionately as 'Aunt Bett,' who is the author of the *Little Brown Bear* books. This house was known locally as the "Upham House."

RAYMOND CASE (JUNE 30, 1903–MARCH 10, 1989). These postcards show Case as an infant and small boy in 1903 and at 21 months. His parents were Edith and Jesse Case. He married Blanch Olmstead on July 30, 1932.

EDITH (ECKLIFF) CASE (MAY 23, 1883–FEBRUARY 6, 1968) AND RAYMOND. Edith's parents were Sarah and William Eckliff. She married Jesse Case on May 29, 1901. She was a member of the Rebekah Lodge 400 and the Women's Society of Christian Service of Flat Rock Methodist Chuch. This image depicts Raymond about eight or nine years old.

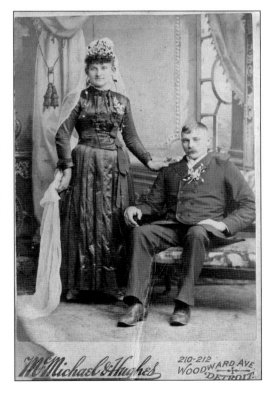

JOSEPH AND ELIZABETH DIEKMAN. This image was taken at Saint Joseph's Church in Detroit on August 10, 1889. They were the parents of 10 children: Herman, Joseph, Bernard, Elizabeth, Henry, Minnie, Marie, Anthony, Arthur, and Earl.

107

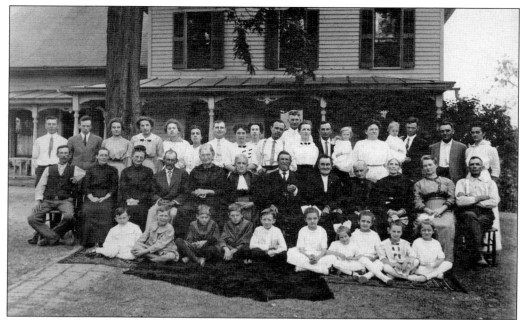

CASE FAMILY REUNION. This 1911 photograph was taken at George and Nettie Case's home, originally a Vreeland house. Hazel's father traded a horse for the front porch. Pictured are, from left to right, (first row) John Langs, Ralph Case, Maynard Flower, Morris Flower, Raymond Case, ? Hooper, ? Parker, ? Hooper, Madalyn Case, and ? Keifer; (second row) John Case, Elizabeth (Lamb) Case, Hannah Burden, Harry Wilton, Maria Wilton, Ellen Young, Hugh Case, Jacob Van Riper, Kit Van Riper Mary Reynolds (grandmother), Nettie Case, and George Case; (third row) Ely Hitchens, Harry Wood, Sadie Wood, Hazel Case, Hilda Case, Hattie Mitchell, Lewis Mitchell, Lila Case, Cora (Case) Langs, Josiah Case, Charles Langs, Edith Case, Jesse Case, baby Leonard Case, Alice Flower, George Flower, baby Flower, and Mr. and Mrs. Walter Hooper.

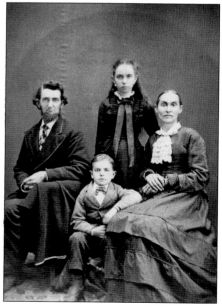

JOHN AND HELEN (PETERS) GARRETSON WITH CHILDREN. John (April 14, 1831–March 28, 1904) and Helen had two children, James (b. June 10, 1868) and Lillis. John's brother was Garret Garretson, who was in the Civil War. (Nancy McHutchion.)

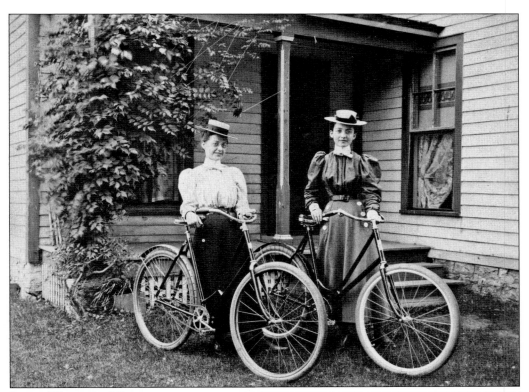

LILLIE (HARRIMAN) LAUTENSCHLAGER, AUGUST 19, 1898. As bicycles became safer and cheaper, more women had access to the personal freedom they embodied. The bicycle came to symbolize the "new woman" of the late 19th century. However, cycling as a means for transport dramatically dropped from 1900 to 1910, when the automobile became the preferred means of transportation.

BRADLEY NATHAN LOBDELL (B. JUNE 20, 1832). He was the brother of Hiram William Lobdell. He married Sabrina Miller on November 7, 1854.

DANIEL GRANBEE LOBDELL (DECEMBER 7, 1813–JULY 9, 1875 IN WASHINGTON, D.C.). He was born in Montgomery County, New York. His parents were Nathan Bradley and Nancy (Richardson) Lobdell. He studied law at Fonda in Montgomery County, New York. He was employed as supervising special agent of treasury with the government during Pierce's administration. He was a sixth generation Lobdell.

DANIEL GRANBEE LOBDELL (MARCH 4, 1861–AUGUST 13, 1932.) He was the brother to John Lobdell. He married Jennie H. Loveridge. When he got married, his father, Dr. Hiram Lobdell, gave them a farm and a furnished house on Will-Carleton.

EMMA A. (MILLER) LOBDELL (B. DECEMBER 10, 1859). She was born in East Troy, Wisconsin. She was the second wife of Daniel Granbee Lobdell (b. March 24, 1861). They were married on April 14, 1886, and had two children: Lelah Lucille (b. March 26, 1891) and Bradley (August 18, 1896–November 12, 1967).

GRACE LOBDELL GLASS (DECEMBER 14, 1882–APRIL 11, 1961). She was the daughter of Daniel and Jennie (Loveridge) Lobdell. She married Earl B. Glass on June 16, 1904, at the First Congregational Church of Flat Rock, and Reverend Hutchinson officiated the wedding. This image is dated June 1912.

DR. HIRAM WILLIAM LOBDELL (APRIL 20, 1826–JANUARY 10, 1884). He was a physician druggist. He married Phoebe Elizabeth Hood on July 24, 1837, and they had two sons: (Dr.) John H. and Daniel Granbee Lobdell.

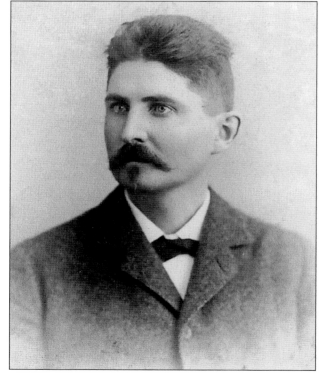

DR. JOHN H. LOBDELL (JANUARY 14, 1860–SEPTEMBER 28, 1931). The son of Dr. Hiram W. and Elizabeth Hood Lobdell, John graduated from the local high school in one of the first graduating classes. He studied medicine at the University of Michigan for two years and then transferred to the Detroit College of Medicine, where he graduated in 1881. On November 2, 1880, he married Alice M. Morey and had two children, Don W. and Hope (died in infancy).

Lelah Lobdell and Bradley Lobdell on December 14, 1900. Lelah (aged 9 years and 9 months in this photograph) was born March 26, 1891, and married George Edward Carter. Bradley (aged 4 years and 4 months in this photograph) was born August 18, 1886. He graduated from Flat Rock High School in 1915 and married Sarah Case. He died November 12, 1967.

Helen Metcalf (left), Irlene (Kerr) Tures (center), and Eunice Metcalf. Irlene was born on November 15, 1899, and died February 17, 1969. Her parents were Sarah (Gay) and James M. Tures. She married Norman Kerr.

JAMES MORRIN TURES WITH EUNICE (LEFT) AND HELEN METCALF (TWINS). Tures was born June 29, 1866, and died March 24, 1939. His parents were Sarah Ann (Van Riper) and Michael Tures. He married Sarah Gay.

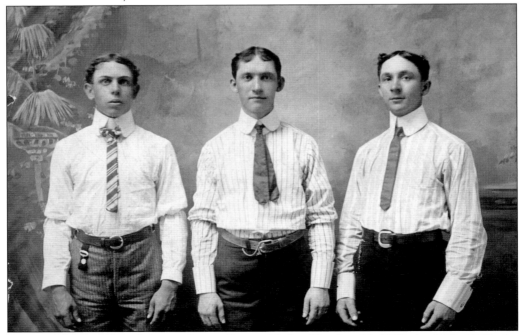

CARSON METLER. From left to right are Carson Metler (October 26, 1883–April 30, 1971), the son of Curtis Metler and Virginia Carson; John Lautenslager; and Ed Lautenslager.

Metler home on Atwater, 1925. This home was the first to have electricity from the mill. The photograph shows Lettie, Virginia (grandmother, b. 1852), and Robert Metler.

Carson Metler (standing) and Harry Reading (sitting). Carson Metler was the grandson of J. G. Carson, who is credited for shooting the last buffalo in the area.

DR. JOHN L. NEAR (APRIL 4, 1808–AUGUST 5, 1895). He was born in the town of Middleburg, Schoharie County, New York, and was the oldest of five children. He came to Michigan in August 1834, where he remained for the rest of his life. He was married to Mary A. Littlefield, and they had four children together. Dr. Near engraved a sword and presented the engraved sword and belt to Lt. Walter H. Wallace when he reentered Company K, 24th Michigan Infantry on August 9, 1862.

FRANK RICE HOME. The caption on the back of this photograph reads, "My father, mother and me and pug dog." The photograph is believed to have been taken on Ypsilanti Street. Frank was married to Selena, and they had a daughter, Alice. Alice (Rice) Stumpmiere was born in 1904 and became a librarian in Flat Rock.

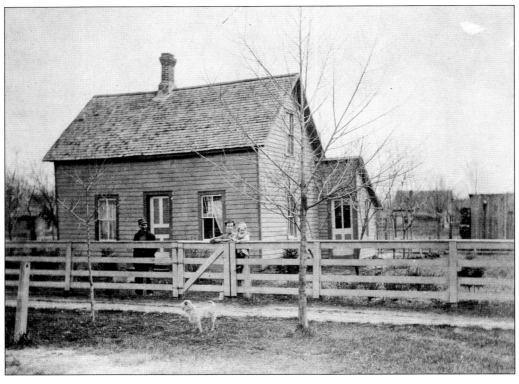

THAD VREELAND, 1898. This photograph was taken after Thad arrived on a boat from Alaska. Thad was the son of Michael Vreeland and Mary Stoflet. His father was a Civil War hero and lighthouse keeper in Gibraltar. He was born in 1865 and died in California in 1910.

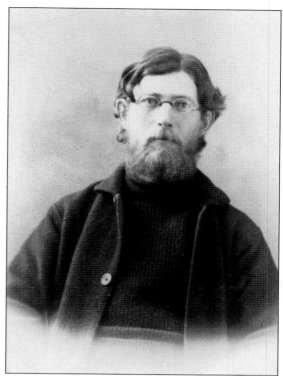

MARY VREELAND COLLINS (B. 1875). Mary was the daughter of Michael Vreeland and Mary Stoflet and sister to Thad Vreeland. She was married to Dr. Ralph Collins.

HALLS AND VREELANDS. Pictured are, from left to right, Frederick Stoflet Hall (b. 1882), Mary (Stoflet) Hall, Mary Vreeland, and Thad Vreeland. Mary was married to Michael Vreeland, who was a lighthouse keeper in Gibraltar. Michael was injured at Gettysburg and died in 1876 at Gibraltar. After his death, Mary continued to run the lighthouse and married Edmund Hall. Frederick Hall became an attorney in Detroit.

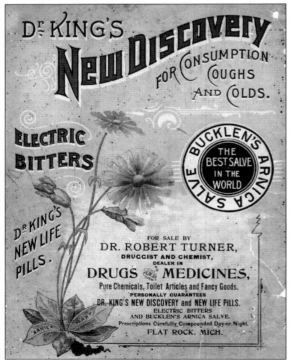

DR. ROBERT TURNER (ADVERTISEMENT). Doc Turner used to tell stories of his student days at the University of Michigan when he and some other young students took a surrey and a team of horses and went out and dug up a corpse. This was a common practice of the time to get cadavers to work on. They would dig a hole into the casket and hook the body out by the chin without ever taking the casket out of the ground. After removing the body, they would set it up on the seat between them. One night, a sheriff stopped them and asked for their names. One of the students made up a name for the corpse and the sheriff replied, "He's kind of stiff," and drove off without knowing it was an actual stiff.

Six

MEMORY LANE

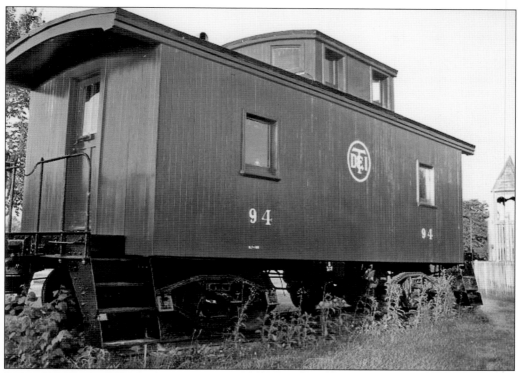

DT&I Caboose. Located near "Memory Lane" is a restored Detroit, Toledo, and Ironton (DT&I) Railroad caboose. It was part of a fleet of cabooses ordered by Henry Ford in 1924. There is a sister caboose at The Henry Ford in Dearborn, Michigan. The caboose represents the great impact Henry Ford and the railroad had on Flat Rock through most of the 20th century. Financed by the Flat Rock Historical Society, the exterior was restored by volunteer members of the society. They are currently working on the interior renovations. (Author's collection.)

FLAT ROCK HOTEL. The Ferstle family built the Flat Rock Hotel during the summer of 1896. The hotel closed in 1998, the Rite-Aid drugstore purchased the property and several adjoining parcels, and demolition of the hotel was scheduled. Through much effort and cooperation by the City of Flat Rock, the Flat Rock Historical Society, and the Rite-Aid chain, the structures were saved. They were moved to Memory Lane in 1999. The two-story porch has been reconstructed and is restored. (Both, Stacey Lee Reynolds.)

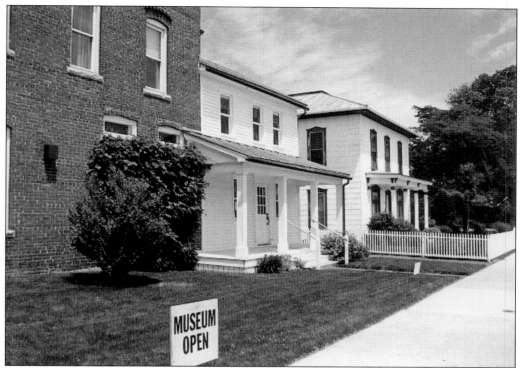

FLAT ROCK HOTEL, GREEK REVIVAL WING, C. 1830. This building, which predates the Flat Rock Hotel, was attached to the hotel and incorporated as a "wing" when the hotel was built in 1896. The style of the "wing" is Greek Revival and dates back to the 1830s when this style was popular. A stable and livery were once located behind the hotel and this building was used as the office. It later became part of the bar area of the hotel. Restoration of this building is now complete. (Both, Stacey Lee Reynolds.)

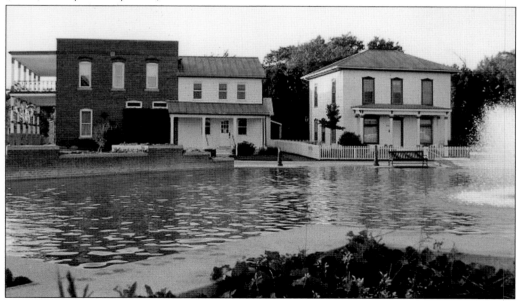

LANGS-WAGAR HOUSE, 1874. Moved in 1999, this house is a fine example of a hipped-roof, foursquare house with balloon frame construction. Brothers Charles and Enoch Lang were Civil War veterans and both injured at Gettysburg. When Charles Lang returned to Flat Rock, he married Esther Thorn. In 1874, he purchased lots 20 and 21 and built this house. They had one child, Susie, who graduated from Flat Rock High School in 1886. After the death of both parents, Susie sold the house on October 17, 1912, to Albert Wagar for $925. Wagar was also a Civil War veteran, involved in a sawmill business, and later operated a steam thresher. Active in community affairs, he was elected town treasurer in 1876 and maintained that position for many years. He was also a town supervisor, a member of the Flat Rock School Board for 40 years, and secretary of the Masonic Lodge for 30 years. In 1923, when the charter was adopted establishing Flat Rock as a village, Wagar served as the first village president. Currently the house is under renovation. (Both, Stacey Lee Reynolds.)

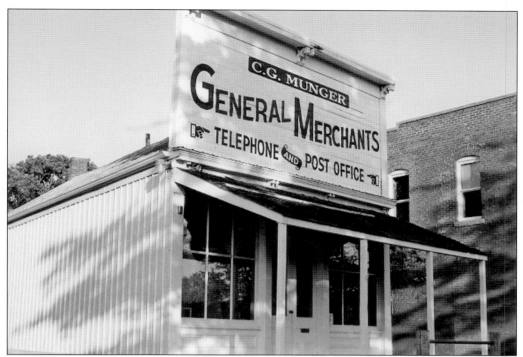

CORNELIUS G. MUNGER GENERAL STORE, C. 1875. This building housed the Cornelius Munger General Store from 1875 until 1937, when the family closed the store with merchandise on the shelves. Lee's Barbershop occupied the building from 1949 to 1969. When the shop closed, the building deteriorated and was slated for demolition. In 1976, the George Diamond family donated the store to the Flat Rock Historical Society with the condition that it be moved and used as a museum. The building was moved to property donated by the Flat Rock School Board, and it was dedicated as a museum in 1985. The Munger General Store is one of the city's oldest remaining commercial buildings. It is also a rare example of late-19th century detached false-front, wood-framed commercial architecture. The building has been recognized for its historic significance with a Michigan Historical Marker. (Both, Stacey Lee Reynolds.)

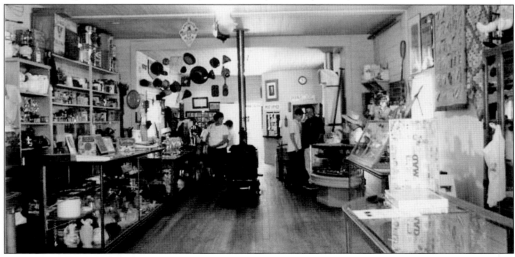

THE "BOBCEAN" STABLE / STOFFLET CARRIAGE HOUSE. This two-story building was originally built by the Stofflet family behind their home on the southwest corner of East Huron River Drive and Seneca Street. It had three stalls and was probably used as a carriage house. It had a cut-stone foundation. Located behind the Bobcean Funeral Home, it was later used primarily for storage and possibly housed the village fire truck at one time. The Bobcean family donated the structure to the Flat Rock Historical Society, and it was moved in 1995. The stable is also open during museum open houses and displays the collection of old farm implements. (Author's collection.)

BIBLIOGRAPHY

Architectural and Industrial Survey Wayne County, MI. Wyandotte, MI: Downriver Community Conference, August 1979.

Bobcean Funeral Home. *About Bobcean Funeral Home.* www.arthurbobcean.com/about.html (accessed September 15, 2010).

Bower, M. *The Iron Brigade: The Twenty-Fourth Michigan Volunteer Infantry Regiment.* www.hmdb.org/marker.asp?marker=4117 (accessed May 23, 2010).

Carter, Sally A. "Winifred Hamilton Collection Dedicated." *The Weekly.* October 16, 2003.

Cousineau, Eugena, Sherry Huntington, and Betty Schley. *The Downriver Seeker Volume 12, No. 2.* Lincoln Park, MI: Downriver Genealogical Society of Lincoln Park, May 1993.

Counsino, Dean. "Vreeland grave marker dedication Saturday." *Monroe News.* September 9, 2005.

Eastern Educator. Ypsilanti, MI: Eastern Michigan University, 2005.

Flat Rock: Parks and Recreation Master Plan 2014. Northville, MI: McKenna Associates, January 20, 2009.

Flat Rock Historical Society. *Our History.* www.flatrockhistory.org/history.htm (accessed June 16, 2010).

Hamilton, Winifred May Oestrike. *Congregational Church.* Brownstown, MI: Winifred May Oestrike Hamilton Collection, Flat Rock Historical Society, Flat Rock Library.

———. *General History 1630-1838.* Brownstown, MI: Winifred May Oestrike Hamilton Collection, Flat Rock Historical Society, Flat Rock Library.

———. *The Huron Indian Reservation Established.* Brownstown, MI: Winifred May Oestrike Hamilton Collection, Flat Rock Historical Society, Flat Rock Library.

———. *Hydro-Electric Power at Ford's Lamp Plant.* Brownstown, MI: Winifred May Oestrike Hamilton Collection, Flat Rock Historical Society, Flat Rock Library.

———. *Water Works.* Brownstown, MI: Winifred May Oestrike Hamilton Collection, Flat Rock Historical Society, Flat Rock Library.

Illustrated History 1876 Atlas of the County of Wayne, Michigan. Reprint, Detroit, MI: H. Belden and Company, 1967.

Lobdell, Julia Harrison. *Simon Lobdell—1646 of Milford, CT and his descendants.* Self-published, 1907.

Nolan, Alan T. *The Iron Brigade: A military history.* NY: MacMillan, 1961.

Slat, Charles. "Few signs of change." *Monroe Evening News.* September 2, 1992.

Srnka, Alfred. *The Brownstown Historical Pageant.* Brownstown, MI: The Flat Rock War Memorial Association, 1953.

Upham, Edward. *The Creamery.* Brownstown, MI: Winifred May Oestrike Hamilton Collection, Flat Rock Historical Society, Flat Rock Library.

INDEX

American Legion Home, 30
Bevier, Luther S., 13
Bunte Brothers General Merchandise, 39
Bunte Brothers Tile Yard, 38
Busick, Arthur A., 73
Captain John Welles House, 82
Carlton, Henry Reverend, 15
Case Farm, 1811 Locust Hill, 76-77
Chief Quaqua Teepee Memorial, 59
DT&I Caboose, 119
Diekman Flour Mill, 41
First Congregational Church, 90
Flat Rock Community Center, 68
Flat Rock Depot, 46
Flat Rock Depot and Museum, 61
Flat Rock Speedway, 55
Gladding, Fred, 102
Henry Ford Headlight Plant, 48
Hiriam Lobdell Home, 81
Kate's Kitchen, 47
Langdon, Ambrose Spencer, 17

Littlefield, Wesley B., 18
Lobdell, John H., 96, 112
Martin, John Robert, 103
Methodist Church, 88
Metler Building, 41
Metler Grist Mill, 42
Mettler, George B., 21
Munger's General Store, 33, 123
Munger, Cornelius, 34
Near, John, 21, 28, 116
Oestrike's garage, 53
Oestrike, Ron, 104
Opera House, 64
Pattee, John A., 22
Pierson, Benjamin W., 23
Steffen, Dave, 102
Turner, Robert, 118
Vreeland, Elias, 26
Vreelandt, Michael, 10
Wallace, Walter H., 28
Water works and water tower, 50

About the Organization

The Flat Rock Historical Society was founded in 1975 when the historic Munger's General Store was threatened with demolition. Residents came together and raised the funds necessary to have this building moved and to open and operate this building as a museum. Through the years, several other buildings have been moved to the same location, to form what people in Flat Rock call "Memory Lane." The museum is open the second Sunday of every month from 1:00 p.m. to 4:00 p.m. A list of upcoming exhibits at Memory Lane can be found on our Web site at flatrockhistory.org.

The Flat Rock Historical Society archives are located in the basement of the Munger's General Store Museum. There is an extensive collection of photographs, maps, and other documentary materials for review. This collection is available to view on the second Sunday of each month from 1:00 p.m. to 4:00 p.m. or by special appointment by calling (734) 782-5220.

The Winnie Hamilton Local History Room is usually open on Wednesday and Saturday from 12:00 p.m. until 4:00 p.m. and is located in the Flat Rock Public Library adjacent to the museum. The daughters of Winnie Hamilton donated her lifelong collection of local historical materials and photographs to the Flat Rock Public Library. With volunteers and support from the Flat Rock Historical Society, the collection was made available to the public on October 4, 2003. Additional family research and obituaries are being added on a regular basis.

Please visit our site at flatrockhistory.org, in person during our open hours, or arrange a special visit by contacting Lila Fedokovitz at (734) 782-1269. Please call ahead to confirm dates and times that the archives and history room will be open. We look forward to seeing you.

www.arcadiapublishing.com

Discover books about the town where you grew up, the cities where your friends and families live, the town where your parents met, or even that retirement spot you've been dreaming about. Our Web site provides history lovers with exclusive deals, advanced notification about new titles, e-mail alerts of author events, and much more.

MADE IN THE USA

Arcadia Publishing, the leading local history publisher in the United States, is committed to making history accessible and meaningful through publishing books that celebrate and preserve the heritage of America's people and places. Consistent with our mission to preserve history on a local level, this book was printed in South Carolina on American-made paper and manufactured entirely in the United States.

Find Your Place in History.